IMAGES
of America

RIVERSIDE

IMAGES
of America

RIVERSIDE

Lonnie Sacchi and Constance Guardi

ARCADIA
PUBLISHING

Published by Arcadia Publishing
Charleston, South Carolina

Printed in the United States of America

Library of Congress Control Number: 2012932289

For all general information, please contact Arcadia Publishing:
Telephone 843-853-2070
Fax 843-853-0044
E-mail sales@arcadiapublishing.com
For customer service and orders:
Toll-Free 1-888-313-2665

Visit us on the Internet at www.arcadiapublishing.com

*This book is dedicated to the Riverside Historical Commission
and its predecessor, the Riverside Historical Society.*

CONTENTS

ACKNOWLEDGMENTS

First and foremost, the authors wish to thank the Riverside Historical Museum for the generous use of their photographic collection and local history files. Unless otherwise noted, all images appear courtesy of the museum. Historical commissioner Kimberly Jacobs donated much of her limited free time assisting with scanning the photographs. We also wish to thank retired assistant police chief Robert Gordon, who furnished much of the information and photographs for the police section of this book. Riverside-Brookfield High School (RBHS) was generous in allowing us access to their photograph collection and archives, as was the Riverside Public Library. Village manager Peter Scalera and public works director Ed Bailey also assisted with the gathering of photographs. James Reynolds provided a contemporary image of the old water tower. Higgins Glass Studio furnished an image of Michael and Frances Higgins. The authors also wish to thank our editor, Jeff Ruetsche, of Arcadia Publishing, for his invaluable feedback as we progressed with the book.

INTRODUCTION

Two recent pronouncements from the National Park Service affirm what generations of Riversiders have experienced while dwelling in the midst of grace and beauty. They are as follows: "The primary significance of the Village of Riverside as a National Historic Landmark is as a designed landscape—one that fully captures the interplay of a holistic, forward thinking design philosophy with the functional necessities of a residential community;" and "Today, Riverside remains a distinguished representation of the extraordinary meshing of landscape architecture design philosophy with suburban development." This book documents the history of this important village, from early settlement through modern times, with an emphasis on the formation of the village.

The location of Riverside was well known to Native Americans as a place of natural beauty with the necessities of fresh water, high ground, and abundant game and wildlife. Its strategic importance was underlined by proximity to the "Chicago Portage," recognized by Marquette and Joliet as a key to control of the Great Lakes and Mississippi watersheds. The transfer of the area to the newly created United States by the Treaty of Paris in 1783 set the stage for the new nation's rapid expansion into the area. By 1828, the Laughton brothers had established an inn and trading post in proximity to the old portage site and it soon became a stop on the stagecoach line. Cook County, today the largest county in Illinois, was established in 1831. The following year brought President Jackson's edict forcing the departure of Native Americans to lands west of the Mississippi River. The first Caucasian settler in what was to become Riverside was Stephen Forbes, who came into possession of 160 acres of land in the area and built a log "palace" for his extended family in 1832. Forbes was elected sheriff of Cook County in 1834 and built a sawmill along the Des Plaines River in 1845.

The revolutionary year of 1848 brought great changes—changes that would permanently transform the area from a backwater to one of great developmental potential. The Southwest Plank Road, following an established Indian trail, was extended to the Riverside area. Today, it forms the southern boundary of the village and is known as Ogden Avenue. The Illinois and Michigan canal, which connected the Great Lakes watershed with the Mississippi River watershed, was also completed in 1848. These two acts opened up the area to commerce and development. When the Chicago, Burlington & Quincy Railroad extended a line to the area in 1864, the locale became easily accessible to the rapidly growing city of Chicago. That same year, David Gage, Chicago's city treasurer, assembled a large equestrian farm and named it "Riverside Farm."

These events were not lost on Emery Childs, who made arrangements to purchase 1,600 acres of Gage's holdings in July 1868. Childs and Gage, along with William Allen, Alpheus Badger, Leverett Murray, Henry Seelye, and George Kimbark, formed the Riverside Improvement Company (RIC) in 1869 with the express desire to create a suburban community that would, in their words, "combine the conveniences peculiar to the finest modern cities, with the domestic advantages of the most charming country, in a degree never before realized." Childs was president of the company, and Gage was the main investor. In order to achieve their lofty goal, they hired the

nationally renowned firm of Olmsted, Vaux, and Company to design and implement a plan that would become nothing less than the prototype of the modern residential suburb. Frederick Law Olmsted saw this commission as a chance to create a place where citizens could simultaneously refresh their minds and their bodies. He believed that generous doses of green space and fresh air would prove to be an irresistible antidote to rapidly industrializing American cities, and that by design one could foster a sense of community in order to create a stronger democracy and attain the highest level of civilization.

Olmsted arrived in Riverside in August 1868 with engineer John Bogart to ascertain the suitability of the site for the proposed suburb. On September 1, Olmsted's preliminary report was issued outlining how the site could be developed into "a suburb of highly attractive and substantially excellent character." The firm of Jenney, Schermerhorn, and Bogart was selected to carry out construction and supervision, and the grand plan was quickly underway. However, it was undercapitalized after early sales struggled and some of the planned land acquisition faltered. The financial failure of the RIC led to the village's incorporation in 1875 in the midst of slow but steady growth. Schools and churches were built, and a rudimentary business district began to take shape. Despite the challenges, Riverside continued to develop true to Olmsted's plan. The state-of-the-art infrastructure, coupled with the semirural feel imparted by the large residential commons and open space along the river, ensured that Riverside would become the model suburb that Olmsted and the RIC envisioned.

The ideal setting of Riverside invited great architecture, and along with William LeBaron Jenney came the likes of Frank Lloyd Wright, William Drummond, Howard Van Doren Shaw, and many others. Riverside also attracted well-known personalities, such as the writer Ring Lardner; Robert Todd Lincoln Beckwith, the last direct male descendant of the slain president; and the notorious Frank Nitti, Al Capone's enforcer and successor as head of the Chicago mob.

Village activities such as local tours, art fairs, and a rousing Fourth of July parade continue to promote the sense of community that Riverside's founders envisioned. Riversiders are proud of their heritage and jealously safeguard the gift that Olmsted gave us. We hope this book helps to introduce our village to a wider audience.

One

PROMISE, PROBLEMS, PERSEVERANCE

In 1869, a veritable beehive of activity descended upon Gage's once placid Riverside Farm as construction commenced. Emery Childs realized that the sooner he had infrastructure in place and lots platted out, the sooner he could sell building sites and generate the necessary cash flow to keep his enterprise afloat. By 1871, the Riverside Improvement Company pointed with pride at the progress already made in a publication entitled "Riverside in 1871." Paved roads, walkways, sewers, gasworks, and waterworks were well underway, and a 200-foot-wide boulevard was planned to connect Riverside to Chicago. A block of stores, a stone chapel, a resort hotel on the Des Plaines River, and over 50 homes had been completed. 300 lots had already been sold. The work being done on the landscape was perhaps the most impressive, with the planting of 47,000 shrubs, 7,000 evergreens, and 32,000 deciduous trees.

Despite these accomplishments, trouble permeated the enterprise from the beginning. Woefully undercapitalized with only $30,000 cash on hand, the RIC issued bonds totaling well over $1 million to finance infrastructure improvements. In June 1869, Calvert Vaux wrote Olmsted a letter referring to the Riverside venture as a "kite flying affair." Further disagreements with Childs led to Olmsted and Vaux ending their association with the RIC in April 1870. William LeBaron Jenney assumed the supervisory duties of the project as the RIC continued to accumulate debt—more than $2 million worth by October 1870. The Chicago Fire in October 1871 precipitated a steep decline in land values, with front footage that typically sold for $300 being reduced to $40. David Gage was induced to release more blocks of land as collateral to keep the RIC afloat, but in August 1872 the RIC had to file for bankruptcy.

Luckily for Childs and the RIC, they were in control of a railroad company that had rights to extend another rail line into Chicago. This valuable commodity enabled RIC to refinance by converting the debt of the company into new bonds, issued by the new Chicago & Great Western Railway Company. This effort provided only temporary relief, however, as creditors began to press their claims for payment. The national financial panic of 1873, coupled with the growing number of lawsuits filed against the RIC, proved to be an insurmountable obstacle for Childs. The RIC faded into obscurity and various lawsuits against it remained unsettled until 1891, when the remaining lots were sold to satisfy the claimants.

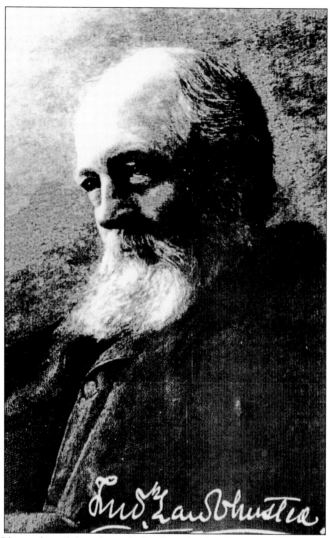

Frederick Law Olmsted, widely acknowledged as the founder of the profession of landscape architecture, was born in 1822 to an upper-middle-class family in Hartford, Connecticut. As a young man, he studied topographic engineering and tried his hand at scientific farming and merchandising before apprenticing as a sailor. On an 1850 trip to Europe, he became fascinated by the English countryside. Back in America, he attempted to forge a career as a journalist, touring the South and reporting on the economic effects of slavery for the *New York Times*. Achieving only modest success in these endeavors, he had not yet found his way when his friend Calvert Vaux asked him to partner in a design competition for what would become New York City's Central Park. Their design won the contest and Olmsted was appointed superintendent and chief architect in 1858. He and Vaux achieved national notoriety. Olmsted served his nation in the Civil War as secretary general of the sanitary commission from 1861–1863 and finished the war years managing a gold-mining estate in California, where he gained an appreciation for Yosemite and the Western landscape. Enticed back to New York City by Vaux, the two formed Olmsted, Vaux, and Company, and worked together until 1872 on some of the most important landscape projects in the nation. Olmsted went on to a long and illustrious career in landscape architecture and died in 1903, confined to an asylum whose very grounds he had designed.

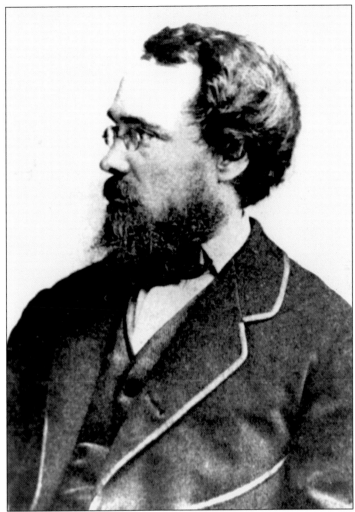

Born in London in 1824, Calvert Vaux was a draftsman, architect, planner, builder, and author. Famed architect Andrew Jackson Downing hired Vaux and brought him to New York to work for his Newburgh-on-Hudson firm. It was at Newburgh that Vaux became acquainted with Olmsted. Vaux was a proponent of "republican art," and the idea that in its physical manifestation, it could serve to improve the lot of mankind. In 1857, he authored "Villas and Cottages," a book of essays and sketches on architecture. After his Central Park collaboration with Olmsted, the two men once again joined together for the 1865 design for Prospect Park in Brooklyn. Their subsequent partnership was a natural fit, with Olmsted responsible for most of the landscape elements of their work and Vaux designing most of the hardscapes, including rustic bridges, boathouses, and refectories. Vaux's involvement with Riverside is thought to be minimal at best, since he was in Europe while the general plan was conceived. His chief importance concerning Olmsted was in encouraging and convincing him that his true calling lay in the field of landscape architecture. After his amicable breakup with Olmsted in 1872, Vaux continued his "republican art" work in partnership with Frederick Clark Withers and George Radford. Vaux was a vibrant presence on the New York City social and cultural scene, where he mingled with the intellectual elite of his day and served as a Fellow of the Metropolitan Art Museum, a member of the Century Club, and a member of the Planning Commission for the Consolidation of Greater New York. He drowned in Gravesend Bay in 1895 while out for a stroll.

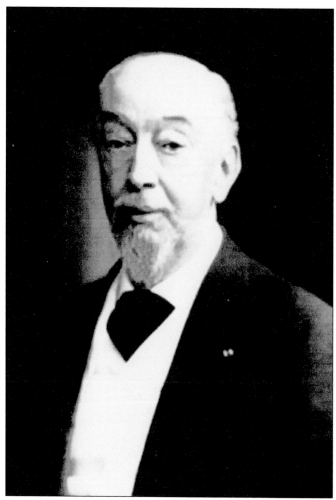

Born in 1832 at Fairhaven, Massachusetts, to a prominent Puritan family of whalers and ship owners and educated in both the United States and Paris, William LeBaron Jenney became one of the celebrated architects and engineers of the 19th century. He was second only to Olmsted in the development of Riverside, taking over the supervision of the project after Olmsted's resignation in April 1870. Jenney had met Olmsted at the Civil War siege of Vicksburg, Mississippi, in 1863, when he was a young engineer attached to Grant's army and Olmsted was inspecting the troops in the field in his capacity with the United States Sanitary Commission. Jenney resigned from the army with the rank of major, which he preferred to be called forever after. Contemporary accounts such as "Western Architect" and "L'Art des Jardins" ascribe primary responsibility for Riverside to Jenney rather than Olmsted. Jenney built his home, Fair Lawn, on Nuttall Road in Riverside. Throughout the travails accompanying the birth of Riverside, Jenney faithfully oversaw the implementation of Olmsted's plan. Along the way, he picked up numerous commissions for some of the village's early homes, a church, the train station, and the water tower. Jenney maintained a lifelong correspondence with Olmsted, and they worked together again on the 1893 Chicago World's Fair. Failing health forced Jenney to relocate to California in 1903 and he retired from practice in 1905. He died in Los Angeles in 1907. Jenney was a romantic and a bon vivant. Without jealousy, he was always in good humor, and despite the fame he achieved as the inventor of the modern skyscraper, he wished only to be remembered as the man who introduced pumpkin pie to Paris.

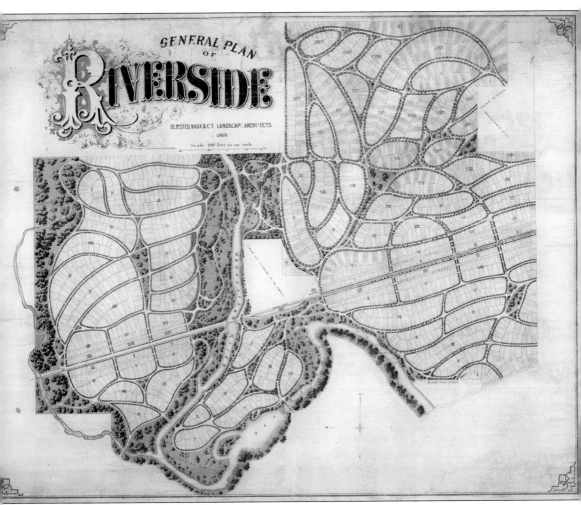

The 1869 General Plan of Riverside is at once a work of art and a masterpiece of urban planning. Riverside is one of the earliest planned communities in the nation and reflects the genius of Frederick Law Olmsted. Out of a total of 2,500 copies originally produced, only three are known to have survived. The 700 acres, nearly half of the 1,600-acre original tract, was set aside as public land; a testament to Olmsted's primary belief that the highest physical and mental wellbeing of mankind could be achieved with favorable attention to the environment. Therefore, he shaped the environment in a naturalistic fashion with the hand of man as invisible as possible.

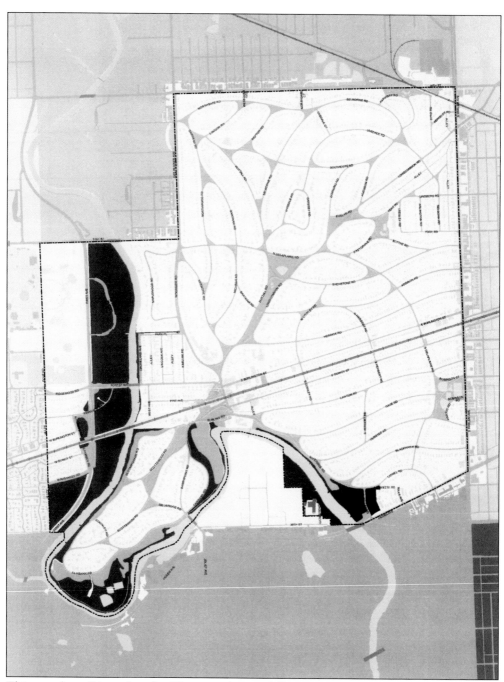

This map shows Riverside today. The most obvious difference is the truncation of the village west of the Des Plaines River. This area, although part of the General Plan, was never acquired by the Riverside Improvement Company, with the exception of a small parcel. Today, it constitutes the Hollywood section of Brookfield, Riverside's neighbor to the west, and is also home to the Brookfield Zoo and Riverside-Brookfield High School. Except for a few minor discrepancies, the comparison of this map with the General Plan illustrates the high degree of integrity with which the village was developed. (Courtesy of Village of Riverside.)

In keeping with Olmsted's and the Riverside Improvement Company's desire to combine the best aspects of urban and rural life, the village was developed with state-of-the-art street lighting, illustrated by this typical gas lamp. Until 1897, Riverside operated its own gas plant, located near the intersection of Harlem and Ogden Avenues.

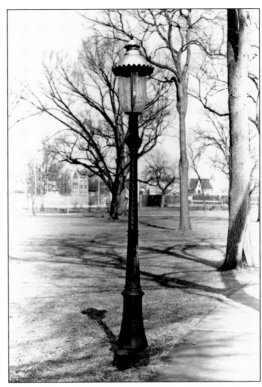

Larry the Lamplighter was a common sight in early Riverside, lighting the gas lamps every evening and extinguishing them the next morning. Larry's salary was paid out of the village's police budget, since street lighting fell under police jurisdiction. Today, the village is still lit by the gas lamps, which are left on continuously. (Courtesy of Robert Gordon.)

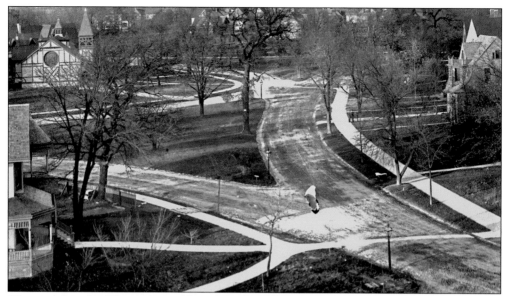

The curved roads of Riverside, seen here from the old water tower, are notorious for getting people lost. Olmsted purposely curved the roads, subordinating ease of movement to a sense of "leisure and contemplativeness."

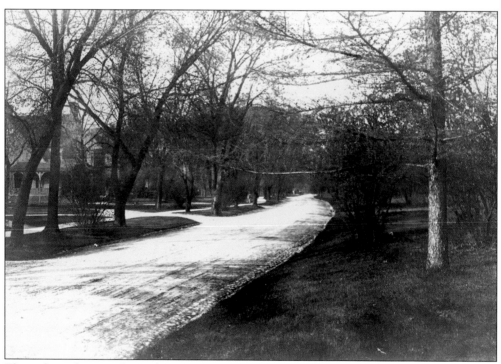

The early roads were of macadam pavement and were drained by cobblestone gutters. They were crowned in the middle for proper drainage and sunken to obscure their view from across the triangular parks, which were formed when the curved roads met each other. Olmsted assigned a high priority to quality pavements and roadways.

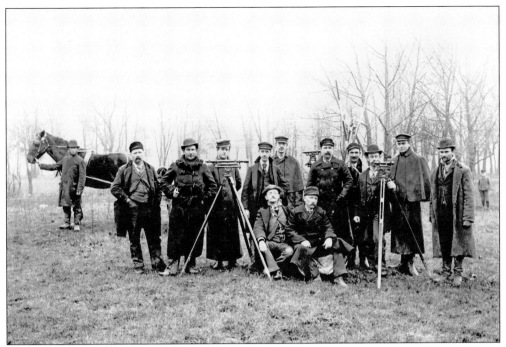

The first three divisions of Riverside were surveyed under the supervision of Louis Schermerhorn, one of the main investors in the RIC, and filed at Cook County in 1869. Much of the northern parts of the village were left undeveloped until the 1920–1940 period. This 1895 photograph shows a team of surveyors at work.

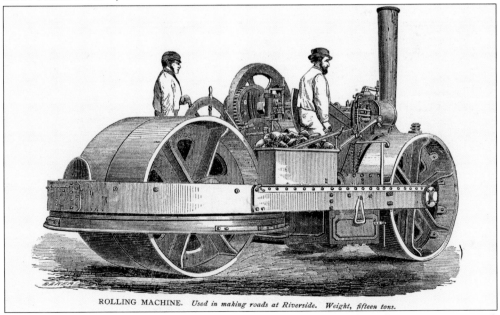

ROLLING MACHINE. *Used in making roads at Riverside. Weight, fifteen tons.*

This 15-ton rolling machine was used to pave Riverside's roads as the village was constructed. It was powered by steam, with the coal box and boiler evident in this illustration. One can only imagine the commotion it must have caused upon its arrival on the site of the once placid Riverside Farm.

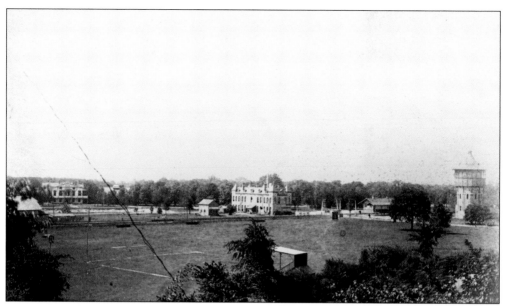

Downtown Riverside still looked very rural in the 1880s. This image, taken from the old school building on Woodside Road, shows, from left to right, the Arcade Building, the old CB&Q depot, and the old ballpark in the foreground.

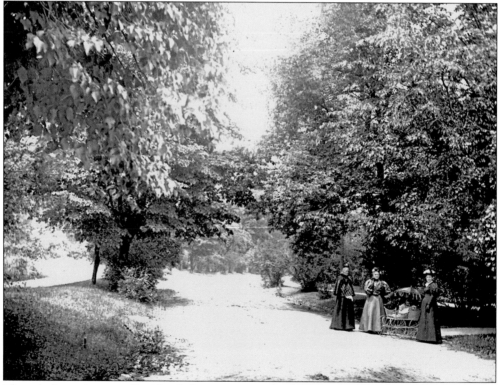

Three ladies enjoy a stroll with a baby carriage in the full bloom of summer. This photograph shows Olmsted's bucolic vision of Riverside as a semirural retreat from the hustle and bustle of the city.

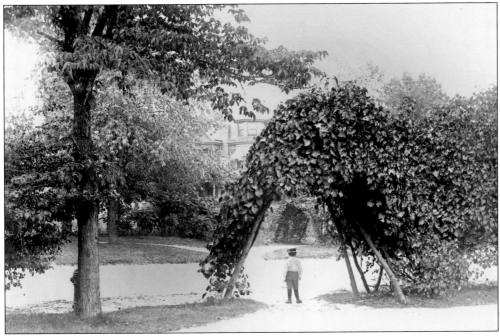

A little boy stands under a vine-covered arbor in September 1892. Scenes like this show the abundance of beautiful, verdant landscaping.

Scottswood Common is one of the great residential commons of the village. It was named after Gen. Winfield Scott, who camped nearby on the high ground along the Des Plaines River on his way to the 1832 Blackhawk War. This view of Scottswood Road shows the 30-foot setbacks mandated by Olmsted to ensure an unbroken view of the greenery. Mandates preserving the original character of the village were enshrined in the 1922 zoning ordinance, only the second such ordinance to be adopted in Illinois.

Swan Pond Park has changed very little since the village's inception. It is still the graceful gathering spot in the center of town at the bend of the river that it has always been. However, since it is a floodplain, it is sometimes rendered useless by heavy rains and floods.

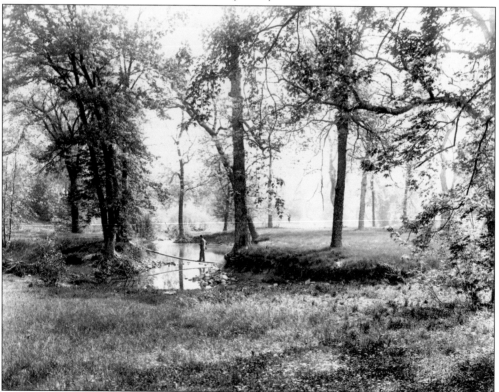

A boy walks across the creek that once flowed around the circumference of Swan Pond Park, forming Picnic Island in the middle. This creek is no longer in existence.

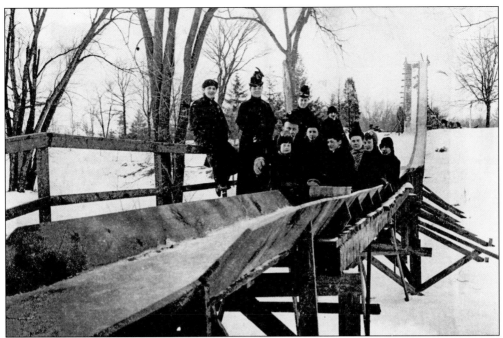

The depressed floodplain that forms Swan Pond Park creates a perfect hill for tobogganing. The large toboggan slide shown in these two photographs was a favorite place for group photographs in any season. In the above photograph, the Kinzie and Ripley families enjoy a winter rendezvous around 1890. The below image shows a group of ladies posing for a late autumn or early spring photograph in 1888. Note the gaslight and the gentle, rolling terrain that forms the park. Neither the toboggan slide nor the light still exist.

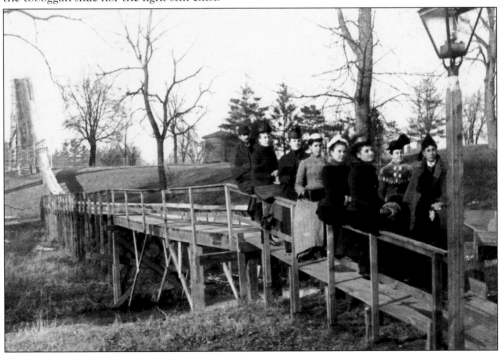

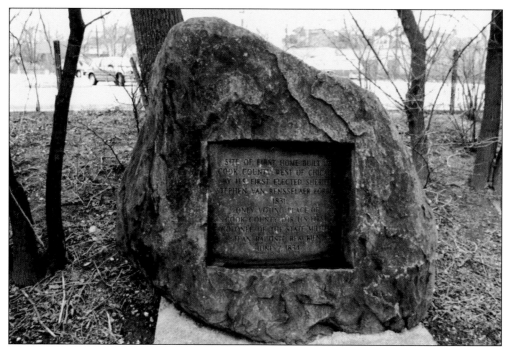

The Forbes marker, marking the site of the first home built west of Chicago in Cook County in 1832, is just west of the train station. Stephen Forbes was the first sheriff of Cook County and from this vantage point could look out at the Des Plaines River and Swan Pond Park.

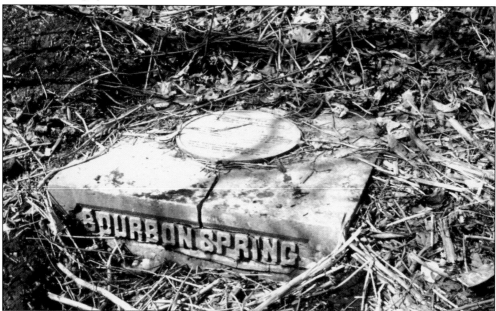

Bourbon Spring was a natural spring in Swan Pond Park that derived its name from the 1834 election of Jean Baptiste Beaubien as the first colonel of the Cook County militia, after which kegs of bourbon were reportedly dumped into the water in celebration. The marker also commemorates the encampment of General Scott in 1832 and the 1837 visit of Daniel Webster, who was greeted here upon his arrival from St. Louis.

Two children stand on the Mill Bridge and peer out at Dr. Fox's mill on the Des Plaines River, just below the old dam. This mill was built on the site of Stephen Forbes's 1845 sawmill and no longer exists.

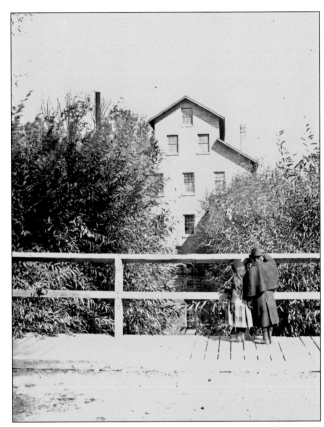

Dr. George Fox's three-story stone gristmill was known as Riverside Mills. It opened in 1866 and was operated by Dr. Fox and his brother Jarvis for the next five years. It continued to operate under various owners until it was sold to George Hermann in 1897. Hermann proved to be the mill's last owner; it burned down around 1900.

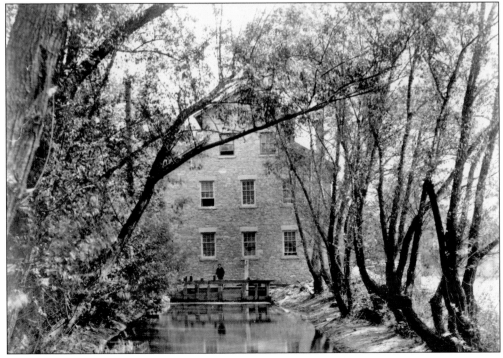

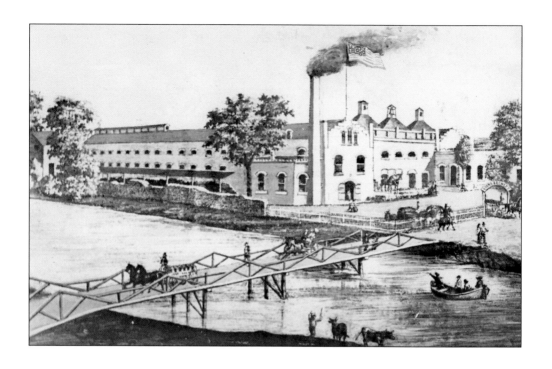

Mueller's Brewery opened for business in 1856, supplying beer to local taverns with their fleet of horse-drawn wagons. It was located just north of Ogden Avenue and east of the Des Plaines River. On a warm October night in 1871, the eastern sky was painted a bright orange as Chicago burned and local residents climbed to the brewery's roof to watch. The brewery itself burned down in 1873, but its ruins (below) survived until the early 1900s, when they were taken down after a wall collapsed and killed a 13-year-old Lyons boy.

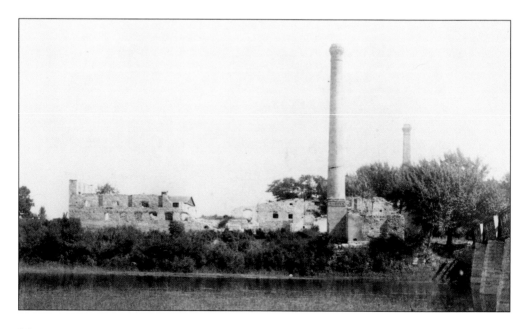

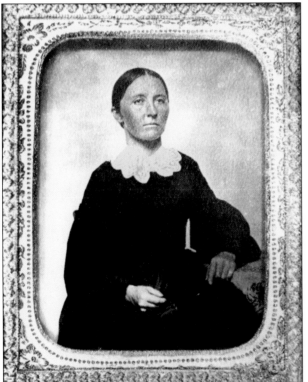

Stephen Van Rensselear Forbes (1797–1879) was the first white settler in the Riverside area. He migrated to Chicago with his wife, Elvira, in 1830, settling just outside of Fort Dearborn. He operated the first school in Chicago and farmed and raised cattle on 160 acres in the area until departing for the California Gold Rush in 1849. After his return to Chicago, he sold the Riverside property in 1855. His daughter Flavilla (below) was the first schoolteacher in Riverside.

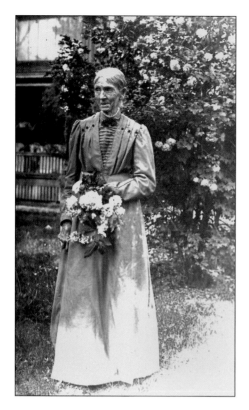

Jane Wesencraft (left) and her husband, William, owned a farm and orchard also dubbed Riverside Farm, in what is now the Pine Avenue area. They sold land for the railroad right-of-way in 1862. When the land parcels for Riverside were being assembled, they refused to convey their property and did not subdivide their farm for house lots until 1889. Their home, which originally stood in the middle of Pine Avenue, was moved to its present location at the time of the subdivision. It is the oldest home in Riverside, dating to 1855. Their daughter Charlotte, pictured below in her garden, lived in the home until her death in 1933.

In 1875, after the demise of the Riverside Improvement Company, the need for a village government became necessary. A petition for incorporation was granted by the State of Illinois and the village was officially incorporated on October 9, 1875. Carol Gaytes was selected by the Riverside Village Board to serve as the first president after 29 votes were cast. He served for two years and died in Riverside in 1883.

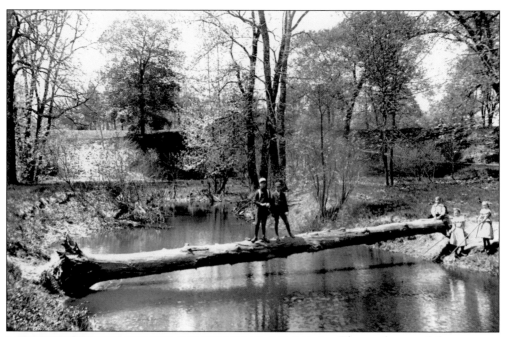

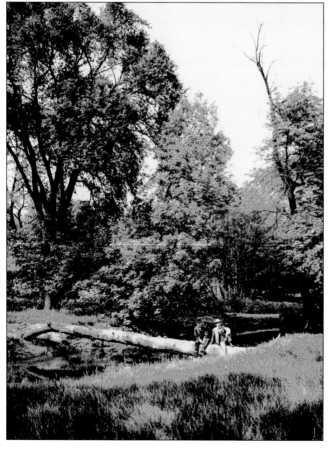

The creek around the perimeter of Swan Pond Park formed an island, known as Picnic Island or Wooded Island to early settlers, before Olmsted arrived. This log across the creek was known as the Natural Bridge and was removed in the early 1900s for safety reasons. As these two photographs illustrate, both young and old enjoyed showing off their bravery by posing on the bridge. When residents began to view the creek as a hazard, it was gradually filled in with dirt and ash, much to the consternation of fishermen who had used it as a favorite fishing spot.

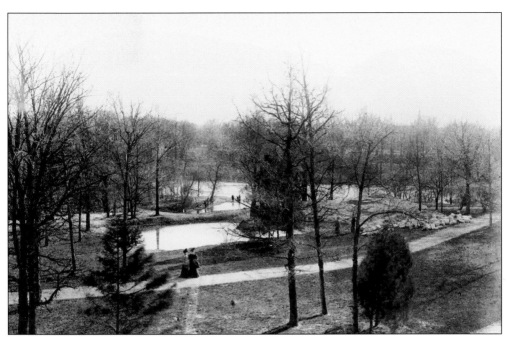

Swan Pond Park was named for the large pond on site, one of several itinerant ponds that formed in the large natural floodplain at the bend of the river. The above photograph shows two women walking in the park alongside ponds with the river in the distance. Below, swans enjoyed the large pond, which gave the park its name. The trail leads up to Fairbank Road, and the Presbyterian church can be seen through the foliage.

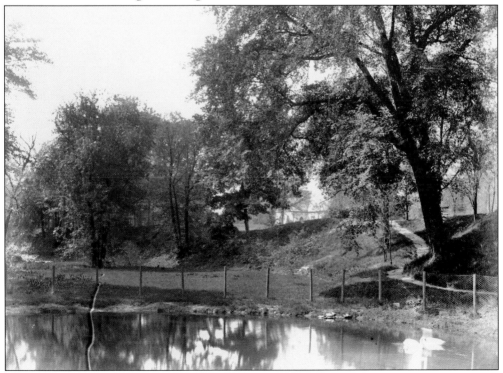

The flow of the Des Plaines River varies greatly with the seasons. Low flow historically occurs during the "dog days" of summer, the long, dry stretches of July and August. The above photograph, taken at the river bend in 1888, shows it at low flow and demonstrates the rippling water and rapids that form as rocky outcroppings are exposed. The same area is seen below during a high water event around 1890. High water events can, of course, also occur in summer during heavy rains, when drainage from the north swells the river.

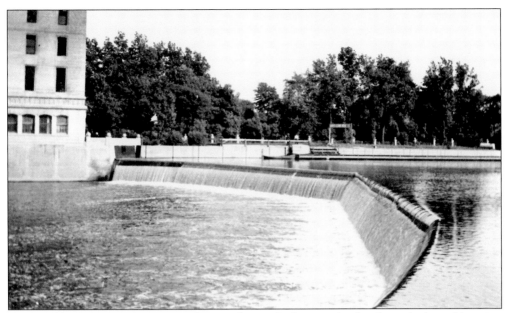

A natural limestone outcropping in the river forms a high point that has been the logical location for a dam since the first one was built around 1828. Both the Forbes and Fox mills were in this general vicinity. The above image, from 1918, shows the horseshoe-shaped dam, which existed from 1908 until the current dam was built in 1950, along with a partial view of the Hofmann Tower and the boat pens in the distance. The below photograph shows the little dam downstream of the Hofmann dam. It is usually referred to as the Fairbank dam, after the street that parallels Swan Pond Park. The date of construction of the small dam is unknown, but it is slated for complete removal as part of a 2012 ecological restoration project, which will also notch the Hofmann dam.

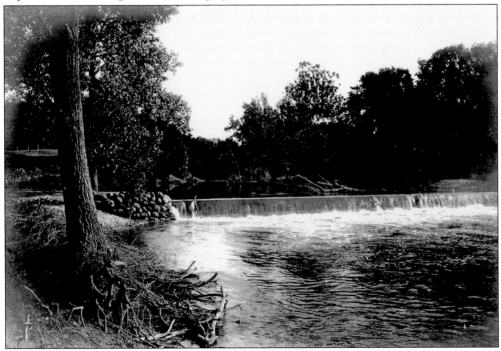

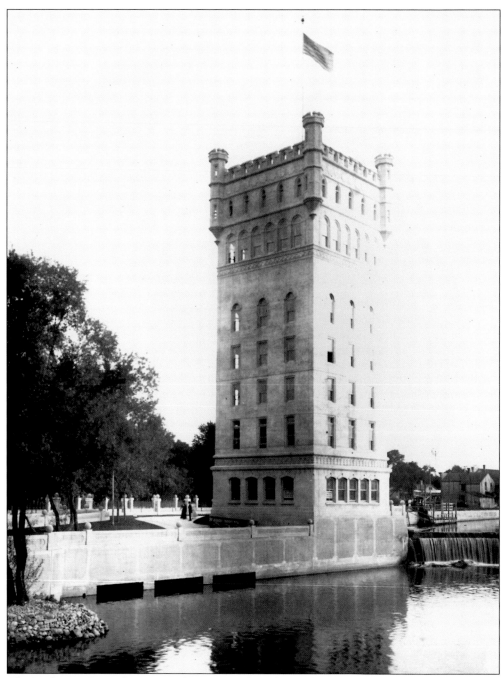

The Hofmann Tower lies across the river in the village of Lyons. George Hofmann built this concrete structure in 1908 as part of a pleasure garden and brewery. He hoped that the river and dam would generate enough electricity to power the array of lights that graced the castle-like structure. When the power generation proved inadequate, he initiated "Niagara Park," a picnic grounds and beer garden, which featured pleasure boating along the river until pollution forced its demise. The Hofmann Tower was one of the tallest buildings west of Chicago and one of the first in the area to be lit with electricity.

Two

SLOW GROWTH, RAPID GROWTH

As soon as the Riverside Improvement Company began to build the village, a rudimentary business district grew up around the water tower and train station. This district provided for the immediate needs of the population as the census count slowly grew. The southern and central districts attracted most of the housing construction, leaving the north end of town to await the population growth of the 1920s and 1930s. Edith Rockefeller McCormick owned many of the lots north of Delaplaine Road, many of which were not sold off until the early 1900s. In 1910, she also platted and sold lots for the Maplewood subdivision. By 1900, twenty-five years after the village's incorporation, the population had reached 1,551, and by 1910, it crept up to 2,532. The village attracted a homogeneous upper-middle-class individual who could afford a genteel lifestyle. In 1962, pioneer resident Bessie Sherman recalled Riversiders having an "active social life, people were intimate and visited often," while children "gathered wildflowers, walnuts, hickories, and wild strawberries on the prairie . . . life was leisurely, gracious, and untroubled."

The rapid social changes in the aftermath of World War I and the age of the automobile both had profound effects on Riverside. They would test whether Olmsted's vision of the ideal suburb would prevail or be consumed by change. Many of the old 100-foot lots were finally subdivided and smaller domiciles were built, instead of the large affluent domiciles of the 19th century. In 1922, Riverside adopted a zoning code as a response to proposals for higher-density development. The proliferation of construction and the advent of door-to-door mail service required a house-numbering system, which was adopted in 1923. By 1930, the population had increased to 6,770. Among Riverside's newcomers was Frank Nitti, who rose from being Al Capone's enforcer to heading the Chicago Mob when Al was incarcerated in 1931.

Many of Riverside's old-timers resented the influx of new citizens, questioning whether they would maintain Riverside values. Tensions rose between old and new Riversiders, with the new migrants feeling shut out from the political process. These tensions came to a head in the election of 1925, when a slate representing the new residents challenged the establishment. This slate won convincingly and instituted changes such as the hiring of a police chief and a village manager for the first time. By 1940, the village had expanded to the limits of the 1869 General Plan and the population stood at 7,935. The newcomers integrated well and appreciated the village's exclusivity and uniqueness. Olmsted's vision had withstood the test, and the village survived the winds of change.

Scenes like this, old farmhouses with wrecked barns, soon gave way to homes, churches, and schools. The above photograph was taken in the spring of 1888. Moments like the one below, with cows grazing on the pasture, would eventually vanish as well, although several farms remained functional well into the 20th century. Stray farm animals were an early nuisance in Riverside, and by 1873, the township passed an ordinance regulating their freedom of movement.

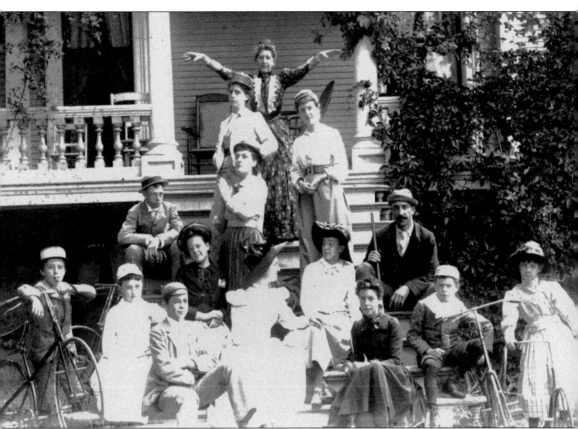

Social life in early Riverside revolved around parties in the large Victorian homes that dominated the village. Everyone knew each other and shared good times and bad. This August 1890 party featured members of the Edward Driver family and their friends at the Driver residence, with Grandma Driver at the top, arms outstretched in welcome. Driver's name lives on in Riverside because of the Driver Monument, the old granite horse-watering trough in Guthrie Park.

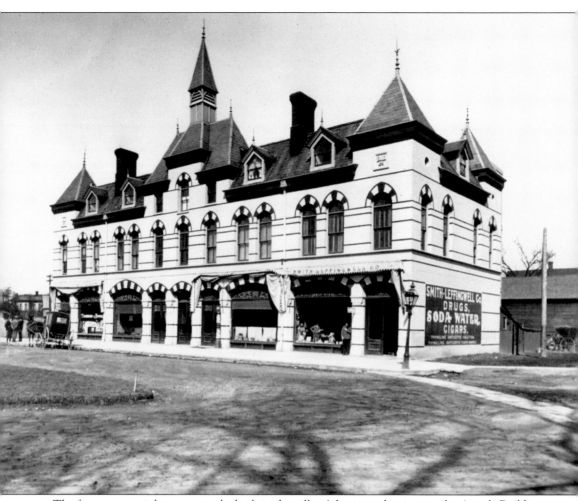

The first commercial structure to be built in the village's business district was the Arcade Building, in 1871. It was built under the auspices of the Riverside Improvement Company and designed by Frederick Clark Withers, a onetime business partner of Calvert Vaux's. It is one of the earliest multi-shop commercial arcades in the nation and housed a grocery store, a market, a post office, and a drug store on the ground floor. The second story was used as the offices of the Riverside Improvement Company and the third floor provided lodging for travelers. The Arcade has long served as the commercial heart of the village and received an intensive restoration in 2010 after falling victim to financial scheming and neglect in prior years.

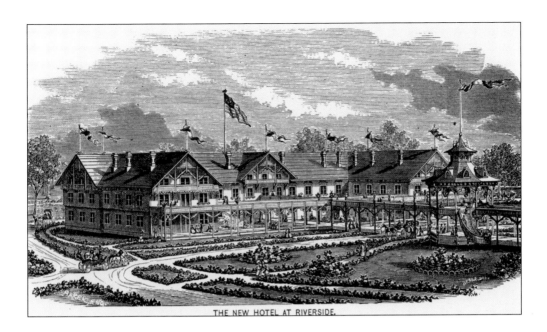

THE NEW HOTEL AT RIVERSIDE.

Anchoring the south end of the business district was William LeBaron Jenney's Riverside Hotel, on a seven-acre site adjacent to the river. The grand resort was the center of social life in the new village and offered a variety of services and entertainment, including a ballroom, a card room, a billiard pavilion, a music pavilion, and reception rooms. One could get a haircut, have a meal, or socialize with the Chicagoans who regularly came out on special trains to escape the summer heat. The hotel had financial difficulties and was almost completely destroyed by fire in April 1887. Only the portion known as the Refectory (below) survived. Local market owner Charles May reopened the Refectory as a hotel in 1905, and it became the private residence of the Ferguson family around 1920. Mrs. Ferguson, remembered as an elegant dowager regularly chauffeured around town in a large green Packard, died in 1945, after which the Refectory was demolished.

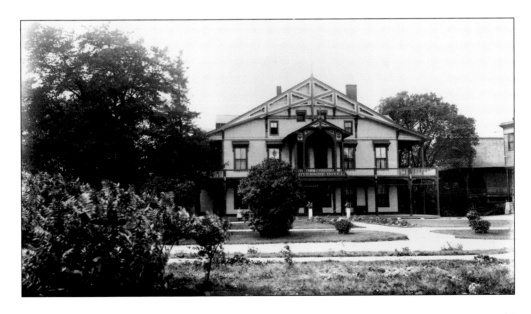

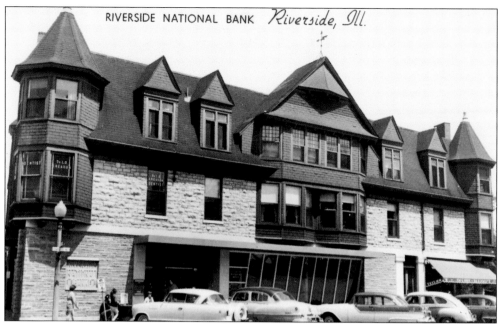

The second commercial building to be erected in Riverside was the Driver Block, also referred to as the Malden Block. The building dates to the late 1880s and was built on a portion of the site of the old hotel. It became the home of the Riverside State Bank in 1907 and seven years later, the bank purchased the building at a cost of $25,000. The corner of the building, on Quincy Street, was the post office. It was here, before the beginning of door-to-door mail service in 1923, that the daily "meeting the mail" social gathering would occur around 5:00 p.m., when residents walked or drove downtown to get their mail. The Driver Block has been much altered since it was built, but it still houses a bank—First American—as it did long ago.

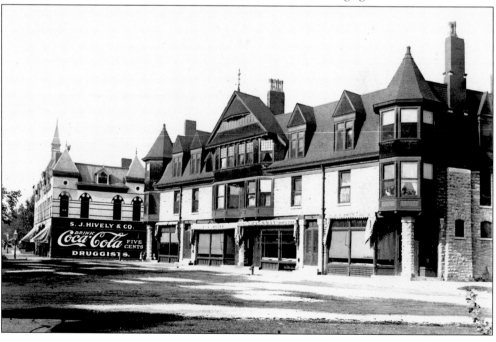

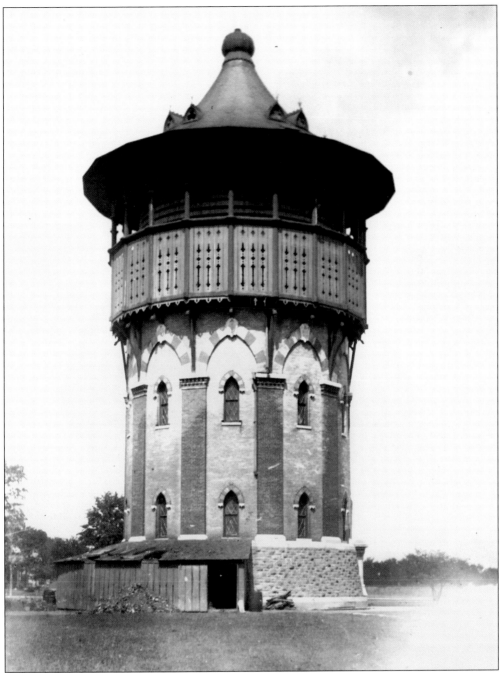

The original 1869 Riverside water tower, designed by Jenney and built at the behest of the Riverside Improvement Company, is seen here with the wooden service sheds attached. Steam pumps were capable of supplying water pressure from the fancy wooden water tank to the third story of any home in the village. The 70-foot-high observation deck was a favorite place to view downtown Chicago. The tower was located in the center of town adjacent to the railroad tracks, in what became known as Water Works Park. The village acquired the land and the waterworks in 1881 for $4,000.

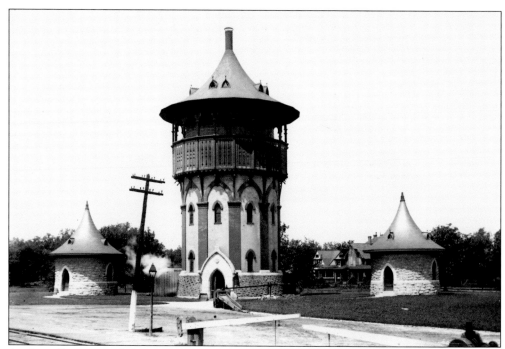

As the village expanded, new wells were drilled and a water reservoir was built. The new well houses (above) were designed by George Ashby and built in 1898. They became popularly known as "Pop and his twins." In 1901, Ashby designed the new pump house (below). At this time, the east well house was rented to the Chicago Telephone Company for use as Riverside's telephone exchange.

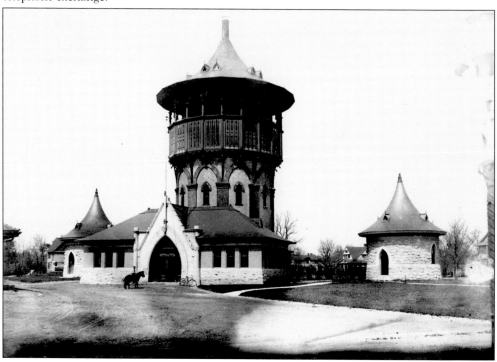

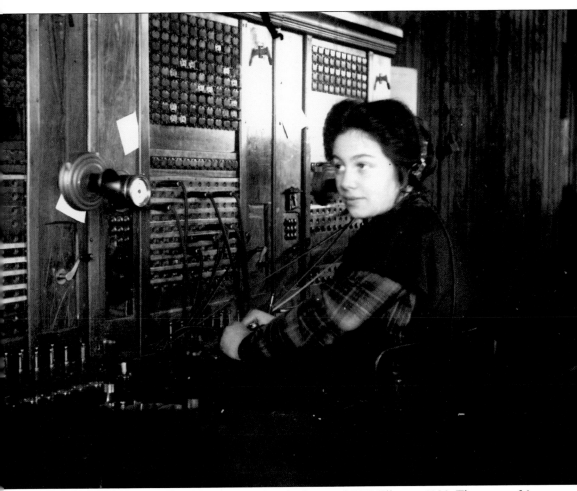

The first telephone switchboard was located at the home of C.W. Elliot in 1900. There were 36 customers. It moved to the east well house at the water tower in 1901 and was operated there until all operations were consolidated in Berwyn in 1916.

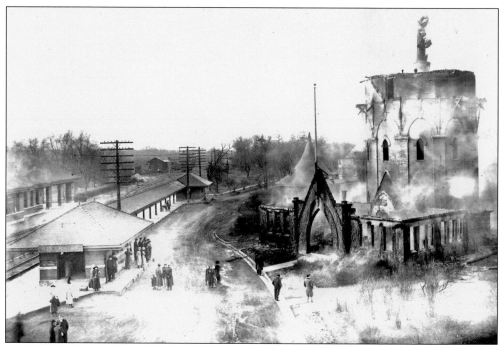

Early in the morning on January 1, 1913, a spark from the coal-fired steam boiler caused a fire, which quickly engulfed the wooden tank. Lack of boiler pressure prevented the fire department from saving the structure, and the tank collapsed into the engineer's room. These images show villagers gathering on the train platform and in the park to survey the smoldering ruins. The telephone switchboard operator in the east well house faithfully stayed on duty until the intensity of the heat forced her evacuation through a window. A water connection with Berwyn was secured to supply Riverside with water until the tower could be repaired.

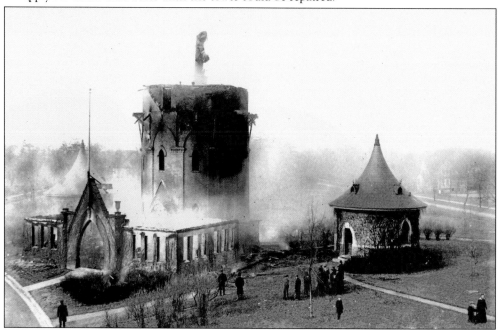

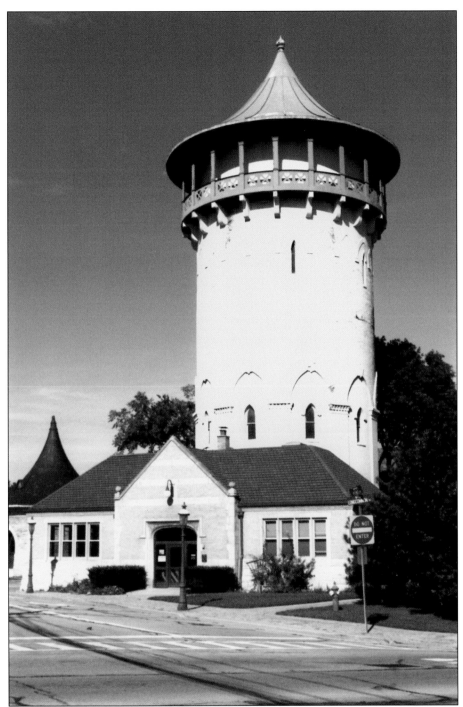

By the fall of 1913, the water tower had been quickly rebuilt, with a new steel tank and a simplified canopy designed by William Mann. It was raised about 20 feet and soon painted over. In 1972, the tower was named an American Waterworks Association landmark, one of only eight in the country. Jenney's trusses, used to support the original wooden tank, are considered a prime example of Victorian ironwork.

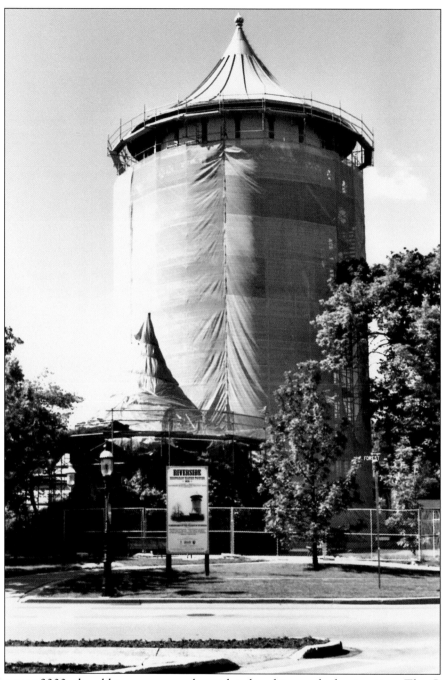

By the year 2000, the old tower was sorely outdated and in need of restoration. The City of Chicago mandated that suburbs maintain a one-million-gallon storage facility and discussions began among village officials as to the best way to meet the needs of the village going forward. A joint solution with the neighboring village of North Riverside was agreed upon. Riverside won a grant for the restoration of the old water tower in 2001, and in 2005 the old tower underwent a comprehensive restoration. The old tower is depicted in this June 2005 photograph while work progressed. It has become the enduring icon of the village.

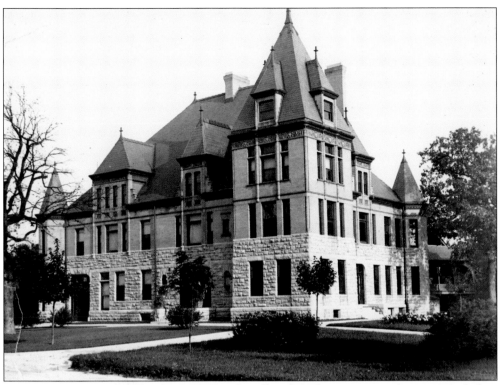

For the first 20 years of Riverside's existence, the village board met at various locations, including the old hotel. An agreement was reached in 1891 between the township and the village whereby the village would provide land and the township would pay for the construction of a new, shared facility. The township authorized $15,000 for construction in 1893. George Ashby designed the Chateau-like structure above, which opened with great fanfare in 1895 with an informal reception and an evening dance. The below photograph depicts the town hall lit up at night, with the 1941 addition of the clock tower—a gift of Grace Sherman Cross in memory of her husband, father-in-law, and son.

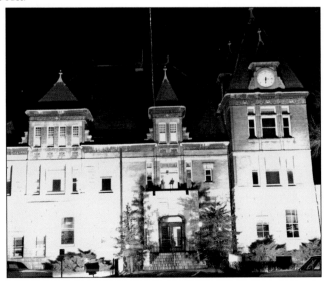

Cornelius Sullivan was Riverside's first postmaster, serving from 1892 to 1912. He was ably assisted for many years by both of his daughters, who served as friendly and familiar faces at the old post office located in the Malden Block. Molly Sullivan succeeded her father as postmaster and served until 1929. Cornelius Sullivan had served as a teamster for David Gage when Gage operated the Riverside Farm. The Sullivan home, located at the corner of Longcommon and Selborne Roads, still stands as the last relic of Gage's farm.

The old bridge across the river to Lyons is illustrated in this image from around 1880. For many years, this bridge served as the main entry and exit point on the south end of the village, adjacent to the old mill and dam sites. By 1913, it was closed by the village for safety reasons and barricaded. Irate residents soon removed the barricades and a new bridge (below) was dedicated later that same year.

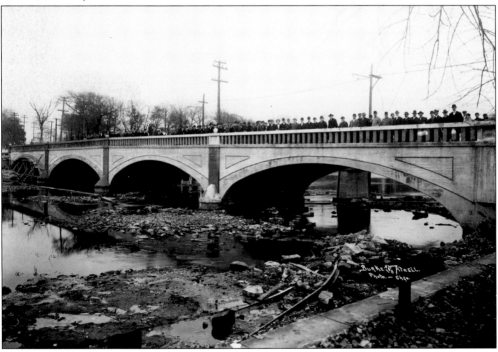

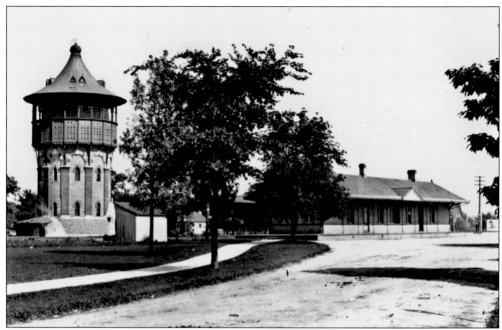

Riverside was built as a rail-oriented suburb and remains so to this day, with the Chicago, Burlington & Quincy line cutting the village diagonally in half. The Riverside Improvement Company commissioned William LeBaron Jenney to design a new train station (above) in 1870 to replace the original station built when the railroad arrived in 1864.

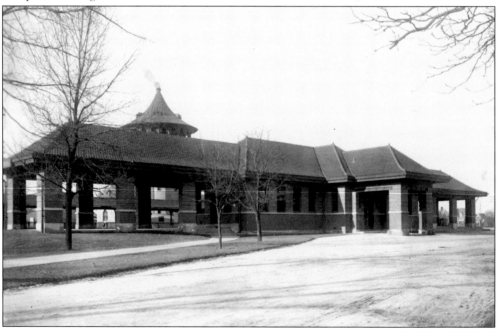

The "Q," as the railroad was popularly known, had its staff architects design a new station for Riverside in the Prairie style. It opened in 1901 and has seen continuous use since then. A covered walkway on the north side of the tracks for westbound trains was built at the same time. The old station was moved to the west and used for freight.

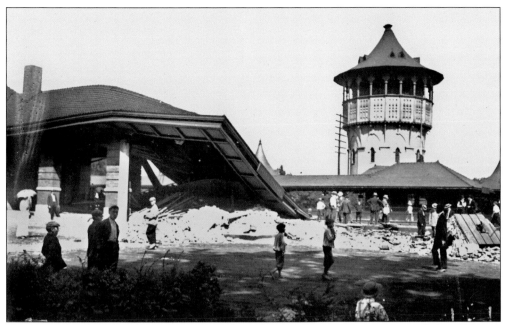

On a warm August evening in 1911, an eastbound passenger train was preparing for its 7:00 p.m. departure for Chicago's Union Station when an eastbound freight train missed a semaphore signal and slammed into the rear passenger car of the departing train. Miraculously, there were no fatalities, but the devastation to the station was considerable (above). The passenger car was thrown from the track and it knocked out the pillar supporting the train station roof, causing the roof to collapse. The below image shows the damage to one of the passenger cars.

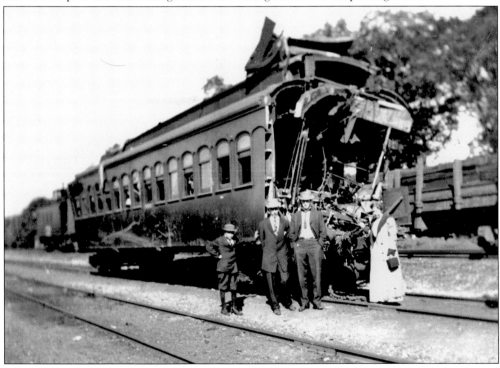

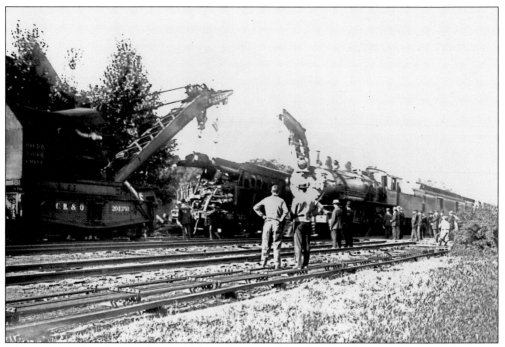

Cleaning up after the wreck was a labor of men and machinery. Cranes arrived on the scene (above) to help right the damaged passenger cars. It was not long before young and old arrived by foot or bicycle, some in straw hats and vests, to help—and to gawk.

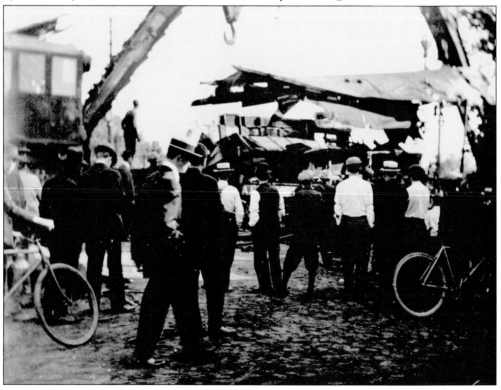

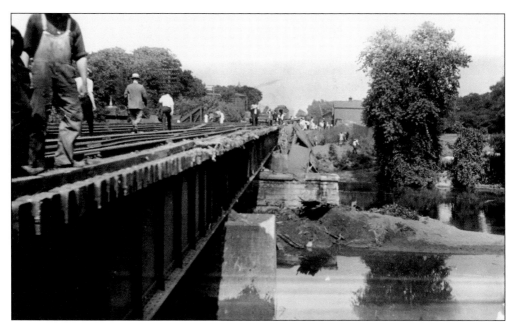

The Chicago, Burlington & Quincy bridge over the Des Plaines River was originally built when the rail line was extended west from Chicago during the Civil War. It has been rebuilt several times, but the concrete trestles date from the Civil War era and are still in use. This photograph, looking east from the river to the train station, shows workmen on the bridge.

Old Otto Petersen, the town handyman and trash collector, had a habit of greeting the morning commuters on the train platform. He lived in the old greenhouse boiler room across the street from Central School and was the undisputed champion of liquor consumption in Riverside.

Prolific Prairie architect Eben E. Roberts designed the Owen-Castle building at the intersection of Longcommon Road and Burlington Street in 1910 for local merchants A.R. Owen and James Castle. Owen's was an upscale grocery store that remained in business until 1968. It was known for its spiffy green Chevrolet panel delivery truck with gold lettering and for the mezzanine-level cashier to whom remittance traveled in a wire-suspended basket.

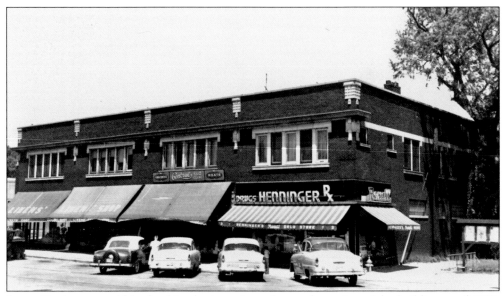

James Castle operated his plumbing business from the south portion of the building until 1941. He continued to live in the apartment above it until his death in 1953. This 1950s-era photograph shows the space after its 1941 remodeling as Henninger's drugstore.

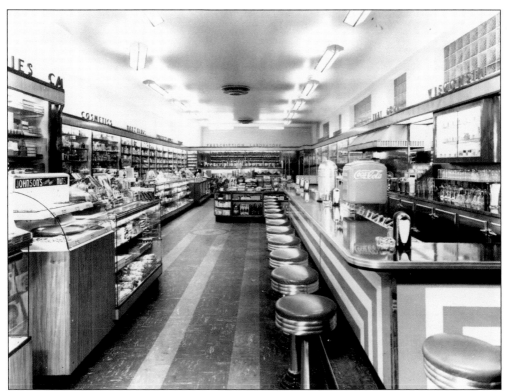

Henninger's was the quintessential neighborhood drugstore, dispensing everything from prescriptions to candy and cigars. The faintly medicinal smell of the interior (seen above) did not stop the soda fountain from becoming one of the local kids' favorite hangouts. The space was sold to Riverside Plumbing in 1985 and remodeled in 2002.

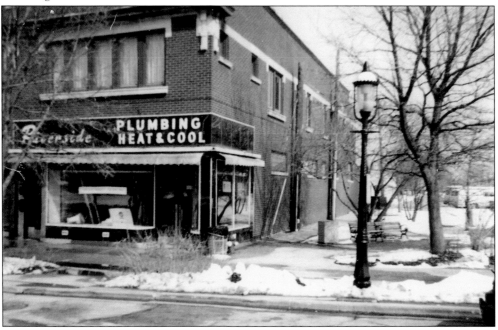

Built in 1936, this structure housed the A&P Grocery store, the first chain store in Riverside. In 1962, Reed Henninger moved his drugstore to this larger location on the northeast corner of Longcommon Road and Burlington Street and continued to operate his drugstore there until his retirement in 1971. Subsequent owners kept the business alive until 1999, but the building was razed in 2006 to make room for a controversial four-story mixed-use building.

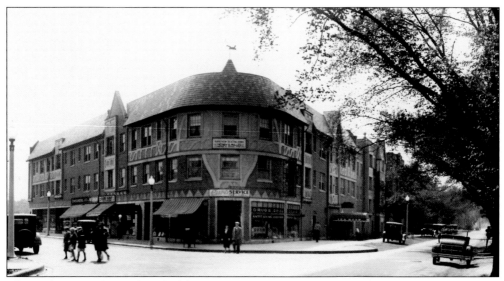

This Tudor Revival mixed-use building was erected in 1929 at the intersection of East and Forest Avenues. The prominent facade was the location of Jindrich's Drug Store and for many years housed Kay Snyder's Arcade Antiques.

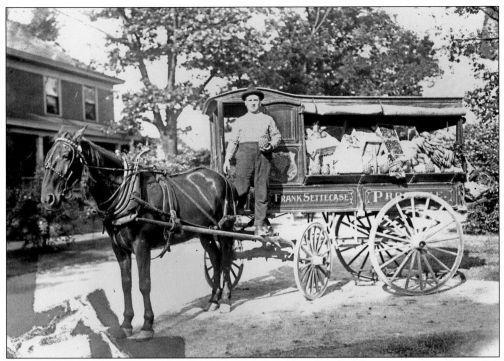

Before fixed locations became commonplace, many peddlers hawked their wares along Riverside's curving roads, calling out their arrival for all to hear. In the upper photograph, Frank Settecase is shown with his produce wagon. Below, the A.R. Owen and the Borden Dairy wagons pause for a photograph near the river.

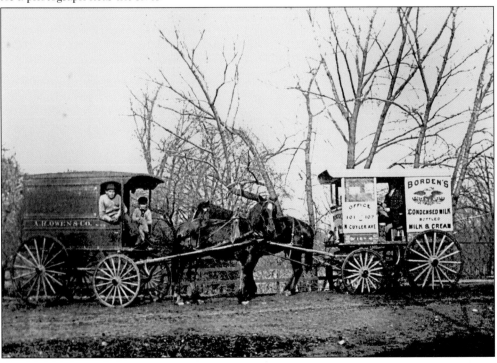

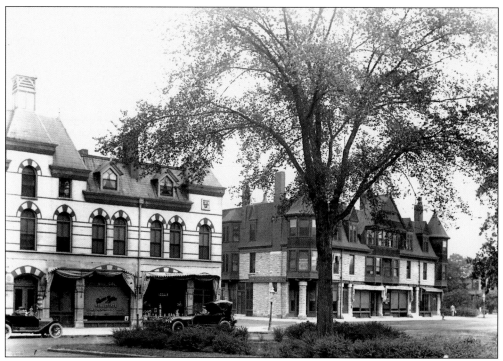

This image, taken on a beautiful September day in 1914, illustrates both the Arcade building and the Driver Block with a typical landscaped triangle across the street. Note the chauffeur-driven Landau, a symbol of wealth and prestige, parked in front of the Arcade.

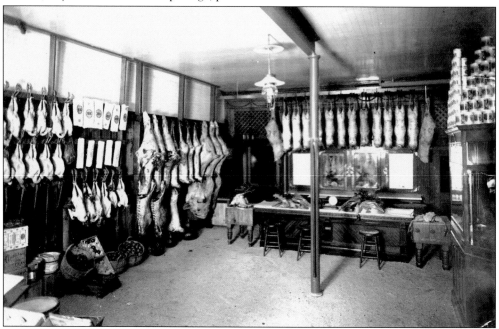

In 1900, the Arcade housed Charles May's butcher shop, complete with elementary refrigeration and sawdust floors. May also operated the second iteration of the Riverside Hotel, housed in the old Refectory.

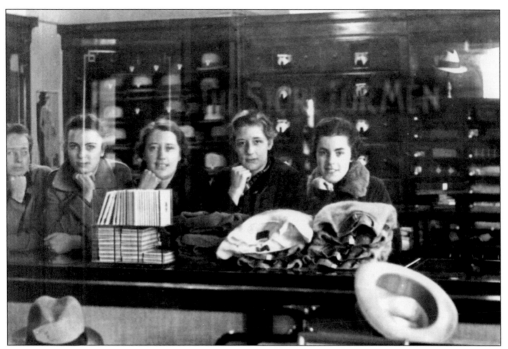

For the Riverside gentleman able to afford new clothing during the Great Depression, Welch's Men's Store, in the recently remodeled Arcade, was the obvious choice. These young ladies pose in the store in 1932.

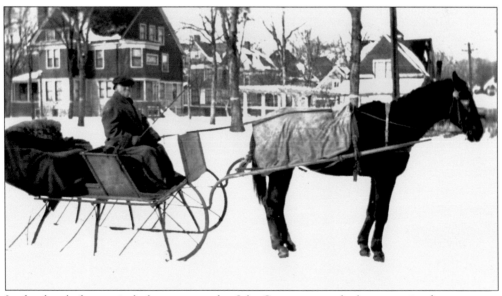

In the days before taxicabs became popular, Jake Opper operated a livery service for passengers arriving at the Riverside train station. In the winter of 1917, Jake was in winter mode, using a sleigh rather than his usual Victoria buggy.

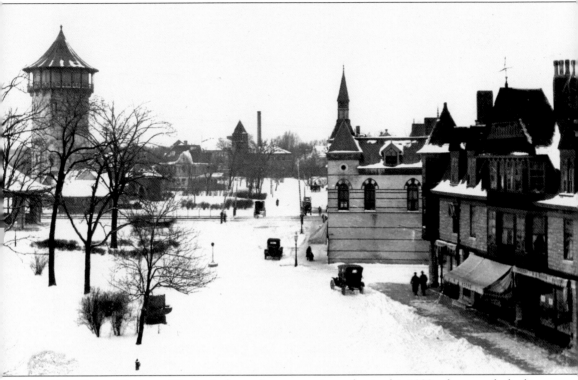

The Central Business District is shown here on a wintry day in this 1920s photograph, looking north from Township Hall. Counterclockwise, from the lower right, is the Malden Block, the Arcade Building, Central School in the distance, the water tower, and the corner of the train station portico. Note the horse-and-buggy traffic coexisting with automobiles and the old horse-watering trough at the lower left. The old trough, known as the Driver Monument, is still in the same Guthrie Park location.

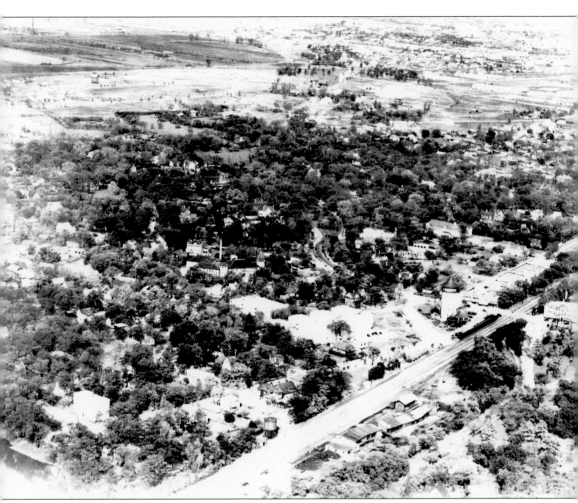

This aerial photograph of the village was taken around 1928 and illustrates the prominence of the railroad tracks through the heart of the village. The large tree canopy over the village's winding streets and homes generated shade and cooler temperatures on hot summer days. The relatively underdeveloped north part of town (top) is seen as mostly flat prairie land, which soon disappeared as the village matured.

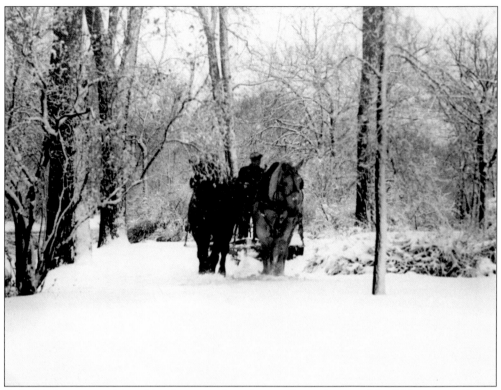

A double-horse team (above) hauls a snowplow along in the early part of the 20th century. Below, a single-horse plow works along the sidewalk in front of the train station. The only creature seeming to enjoy this work is the dog.

As late as 1937, the double-horse team was still responsible for snow removal on Riverside's sidewalks. Here, Martin Steinhoff is at the helm.

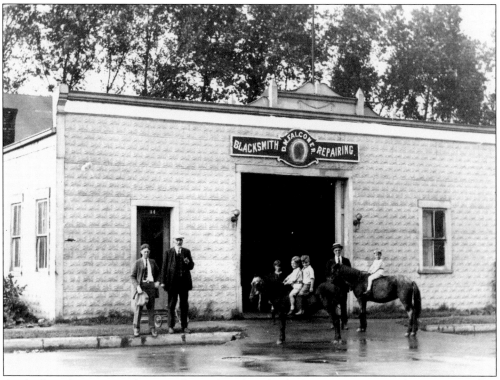

As the horseless carriage became the preferred method of conveyance, many businesses made a similar transition. The old building where Don Falconer shod horses at 36 East Quincy is shown here in 1918. Falconer's mechanical aptitude soon led him into the field of repairing automobiles, and his twin sons carried on the business after 1941.

In the above image, Thomas Martin is pictured on his horse, Maria, in his yard behind 69 Lincoln Avenue, now the site of the Martin Manor Condominiums. Thomas Martin and Maria led the annual Fourth of July parade for many years. Martin established a feed grain and fuel business on the south side of the railroad tracks just west of the depot in 1892, later concentrating on the coal business as automobiles replaced horses. He ran the Martin Coal Company until his death in 1947. Management was transferred to his son-in-law, Roland Edgerton, seen below standing in front of the company around 1940. That spot is now the site of the Riverside Swim Club.

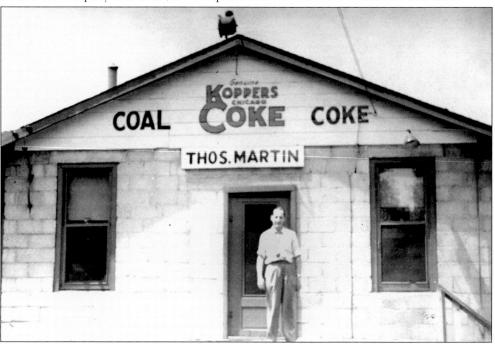

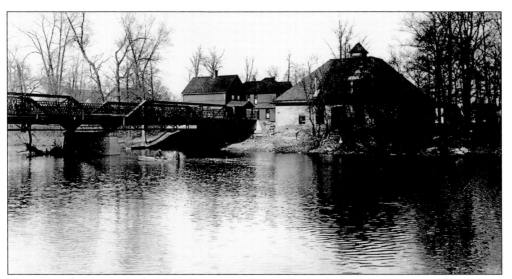

The Riverside Electric Light Works, a project whereby Riverside would generate its own power, is shown at its location on the southeast bank of the river at the Forest Avenue bridge. The project never materialized and the structure was eventually used as Edwin Davis's artist studio.

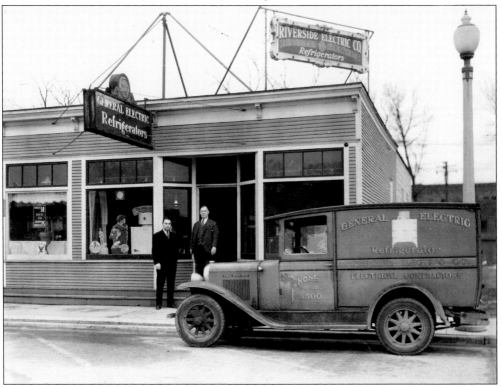

Charles Osberg and his son Theodore posed in front of the Riverside Electric Company in 1927. The Osbergs were responsible for wiring many of Riverside's homes for electricity. Note the promotion of refrigerators, a symbol of progress as the age of electricity made life easier for all Americans. Next-door was Adam Damit's barbershop, where haircuts were 50¢ for adults and 25¢ for children.

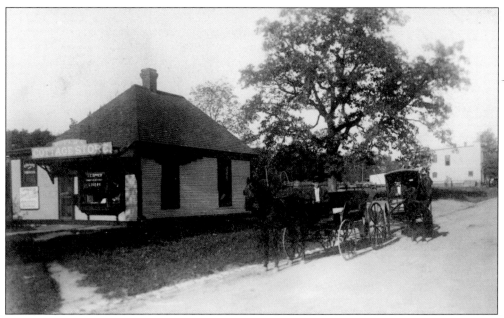

Besides his busy livery service, Jake Opper managed his "Cottage Stop" convenience store, seen here in 1915, on the northeast corner of Longcommon Road and Burlington Street.

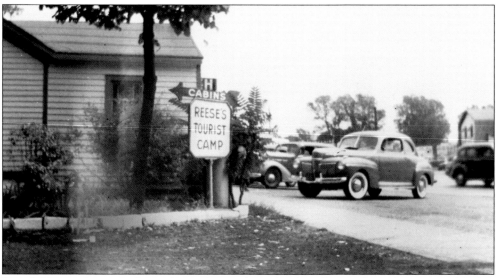

Reese's Tourist Camp was located near the southeast border of Riverside at the corner of Ogden and Harlem Avenues. It offered small cabins for rent to motorists, many of whom were headed west on the famed Route 66.

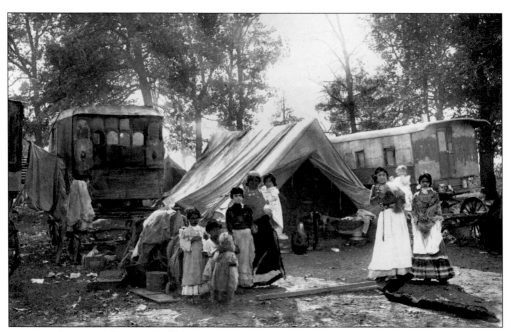

Just outside Riverside's northerly border stood the site of the old hobo camp (below) in what is now the village of North Riverside. The above image is of the gypsy camp south of the village. Children were warned by their parents not to venture very far either north or south, where evil of all sorts awaited them if they fell under the sway of the hobos or the gypsies.

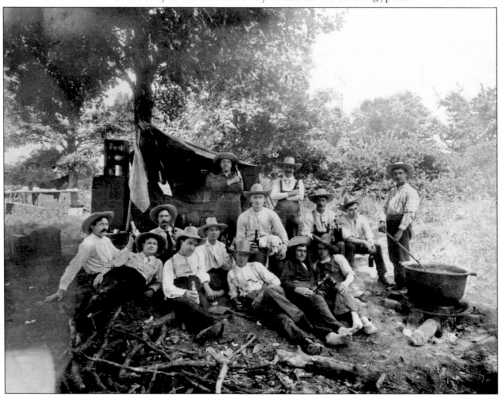

The rise of service stations in Riverside was further evidence of the age of the automobile. The Socony Gas Station at 20 East Quincy Street is seen above in the 1930s. Below, seen in an image from the same era, is the Shell Station at 49 East Burlington Street, whose building later became the Yellow Cab Company.

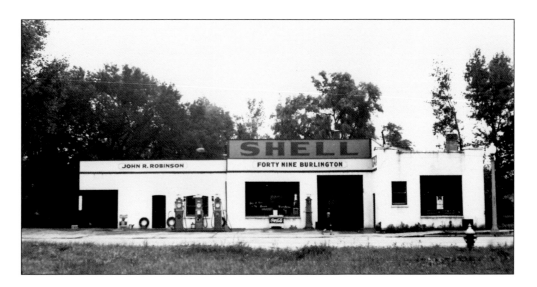

As in most locales, full-service stations declined in Riverside with the advent of modern self-serve stations with attached convenience stores. This service station, once a thriving Martin's Pure Oil station and later a Sunoco station, is now the site of nine townhouses at 315 East Burlington Street.

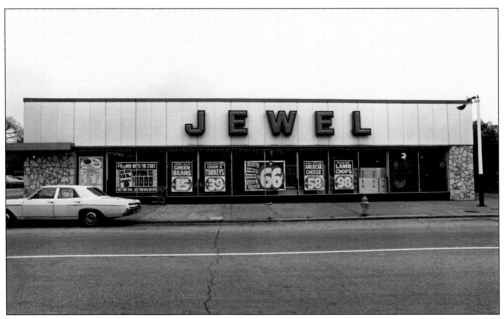

Many Riversiders will instantly recognize this location as the place to shop for their weekly groceries. This photograph shows the building when it housed the Jewel Food Store. It is now Riverside Foods.

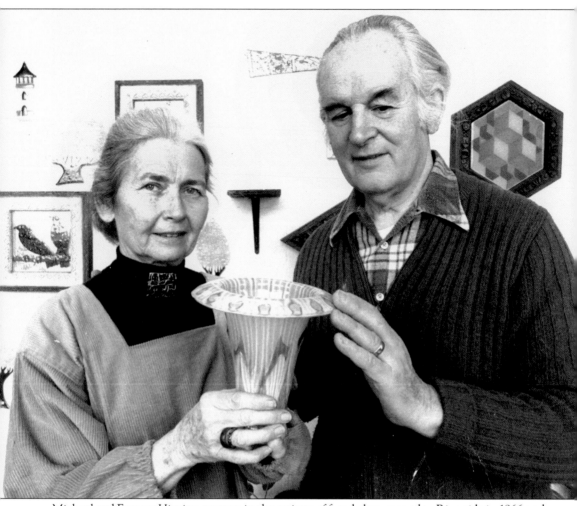

Michael and Frances Higgins, masters in the artistry of fused glass, moved to Riverside in 1966 and operated their studio at 33 East Quincy Street for the rest of their lives. Their work has achieved worldwide renown and is displayed at the Smithsonian, the Metropolitan Museum of Art, and other international institutions. The studio continues to operate today and is especially popular at Christmastime. (Courtesy of Higgins Glass Studio.)

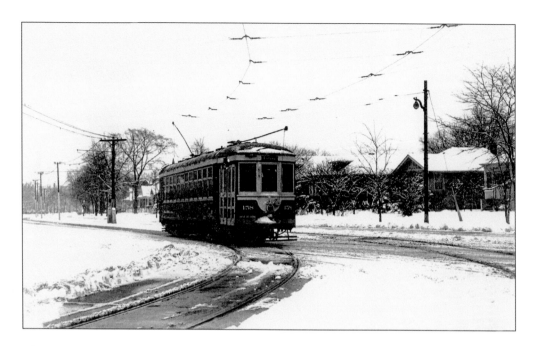

The Suburban Electric Railroad Company operated a trolley line from Chicago at Riverside's northern border along Twenty-sixth Street. It turned south on Des Plaines Avenue and Woodside Road and then proceeded west along Park Place over the river to the Brookfield Zoo, terminating at LaGrange. Popularly known as the Tooterville Trolley, it was a ramshackle affair that creaked and rocked its way through the village for over 50 years before making its last run in 1948. Above, the old No. 158 makes a turn onto Park Place from Woodside Road. Below, a group of passengers crosses the river on their way to the zoo. The grass median on Woodside Road was once the rail right-of-way.

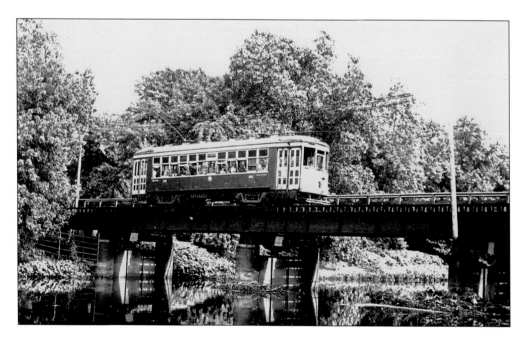

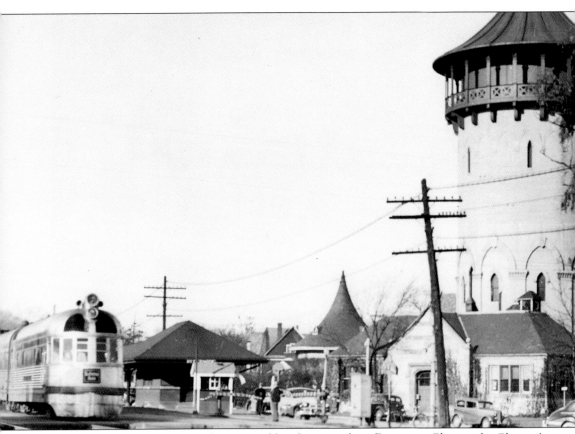

The streamlined "Zephyr" made its record-breaking run from Denver to Chicago for Chicago's 1933–1934 Century of Progress exhibition, covering the 1,015 miles in 785 minutes for an average speed of 77.6 miles per hour. The Zephyr, shown at the Riverside train station, pioneered diesel-powered streamlined passenger service in America.

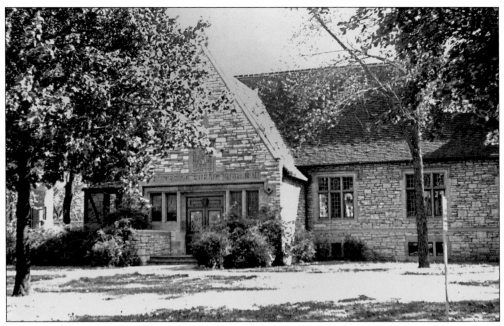

Although it took over 60 years for Riverside to establish a public library, the result was worth waiting for. The English-Gothic-style building of cut limestone was built in 1930 and designed by the prize-winning architectural firm of Connor, O'Connor, and Martin. The L shape, with separate wings for adults and children, was considered a cutting-edge design at the time. A separate L was built in 1986 to complete the rectangle that we enjoy today.

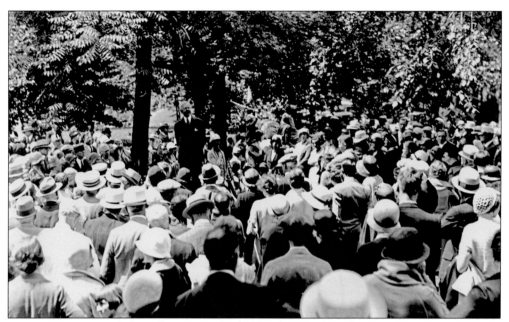

In 1927, voters overwhelmingly supported a $75,000 bond referendum for the construction of a public library while turning down the opportunity to allow movie theaters in the village. Otto Reich is seen here delivering the dedication address to the large crowd that turned out for the library's dedication in April 1931. In the first 10 days of operation, the library issued over 1,400 cards to residents.

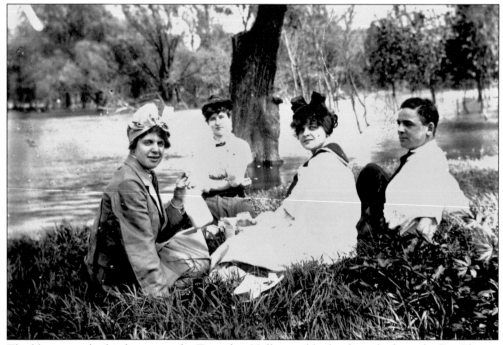

The library was built adjacent to the Township Hall on public land overlooking the Des Plaines River and Swan Pond Park. A typical library patron could sit on a window seat overlooking residents quietly picnicking in the park.

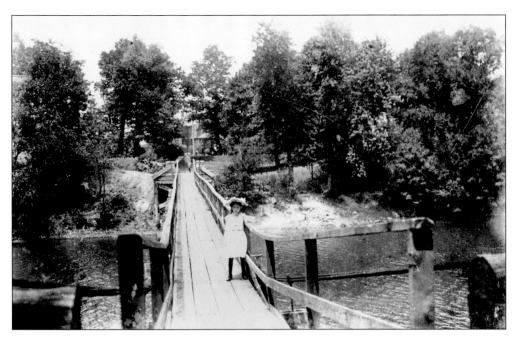

The unincorporated area known as Riverside Lawn lies immediately south of the bend in the river across from the old hotel site. Alexander Watson acquired much of the area in the late 1800s and it became known as Watson's Island. In order to promote the area for development, he built this bridge across the river to Riverside in 1893 after winning a lawsuit with the village for the right to do so. The bridge was popular with hotel guests as a place for a stroll. Below, Ruth Manning poses on the bridge in 1895.

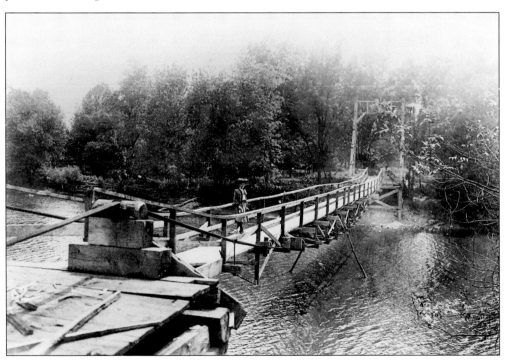

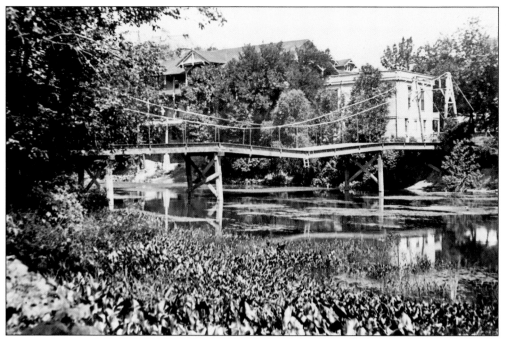

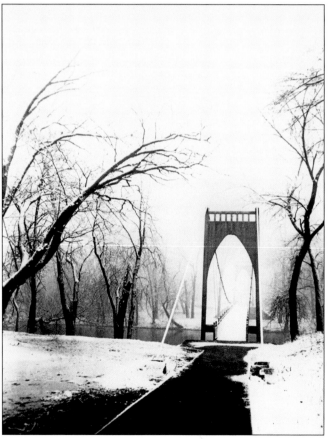

The upper photograph shows the second bridge connecting Riverside to "The Lawn." This improved suspension bridge was erected around 1905 after Watson's bridge was deemed obsolete. The rear of the old hotel is seen in the background. The current bridge (left) was built in 1940 and renovated in 2002. Although officially known as the H. Wallace Caldwell Bridge, everyone refers to it as the Swinging Bridge after the popular Riverside habit of walking out to the middle and rocking the bridge so it swings. The bridge is still used by children on the way to Central School and by commuters to and from the train station.

Three

THE VILLAGE MATURES

While successfully navigating through the rapid growth of the 1920s and 1930s, Riverside's governing institutions adapted to the demands, gradually modernizing their operations. The adoption of a zoning ordinance and a house-numbering system along with the hiring of a full-time village manager and police chief occurred in the early 1920s. A successful referendum in 1937 brought about organized recreation to Riverside with the establishment of the Parks and Recreation Department.

In the early years of the village, whenever a fire broke out someone would run to the schoolhouse to ring the bell and anyone within range was expected to haul hoses to the scene and put out the fire. This was known as the "everybody help" plan and eventually proved inadequate. By 1897, the fire department had acquired two hose carts and a hook and ladder wagon. On November 7, 1898, the village board passed an ordinance formalizing the department. In 1901 the department became a paid-on-call operation, which it remains to this day.

From its inception, the village recognized the need to maintain law and order. Less than a month after the village's incorporation in July 1875, Riverside employed both a constable and a police officer. Charles Teale was Riverside's first officer and soon rose to the rank of sergeant in October 1875. One of his duties included maintaining the pound for the detainment of stray animals, whose owners were fined $1 for each infraction. As the village slowly grew, extra officers were needed and special officers were hired as the occasion warranted. By the end of the century, the officers' duties had expanded to include the collection of pet licenses, peddlers' fees, telegram deliveries, water shutoffs, and the inspection of outhouses to make sure they were connected to the village's sewer system. When the age of the automobile arrived, most complaints centered on speeding. In 1902, the village passed an ordinance setting a speed limit of eight miles per hour. By 1917, Riverside was regularly employing three officers, with Sergeant Lange receiving $100 per month and two specials at $90. The first motorized conveyance for police officers arrived in 1918 when the village purchased a Harley-Davidson motorcycle for $342. The village's rapid expansion in the 1920s brought the advent of the modern police department with the establishment of a chief of police position in 1925 and the addition of two squad cars in 1926 to augment the motorcycle. Squads without radio communication had to rely on WGN radio to broadcast information until two-way radios became common in the 1930s. A police auxiliary corps was formed in 1942 to assist with law enforcement due to manpower shortages caused by World War II.

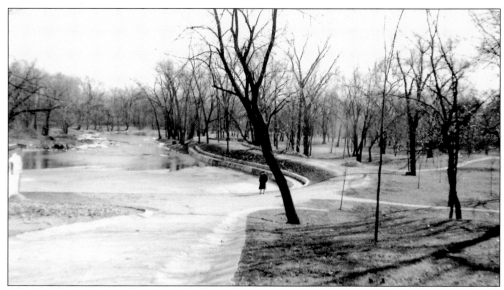

The Works Progress Administration (WPA) arrived in Riverside in 1934 and conducted many projects in the village, including the revetment of the riverbanks in Swan Pond Park and Indian Gardens Park. A 150-foot dike was completed with slabs of hauled-in concrete, which were broken up on site and set along the riverbank. Any remaining trace of the old creek around Picnic Island was erased at this time when Swan Pond Park was regraded to assist drainage during flooding. The WPA also built tennis courts, concrete benches, and an addition to Township Hall. They continued their efforts in Riverside until 1939.

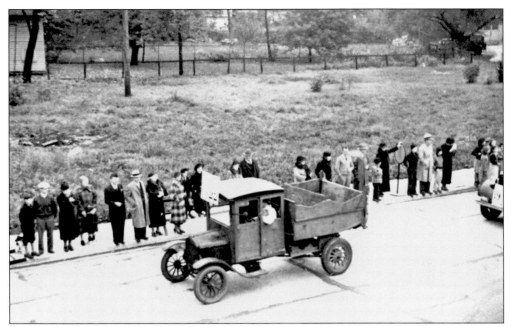

As the village grew, so did the volume of trash in need of disposal. A public works function grew from a simple horse-drawn wagon in the 1920s into a mechanized department with equipment to match. The first truck was an old cab salvaged from the scrap heap and converted into a work truck. Riverside showed off its first garbage truck (above) at the 1936 centennial parade. Below, in 1940, the garbage department was complete with six public works employees and three trucks.

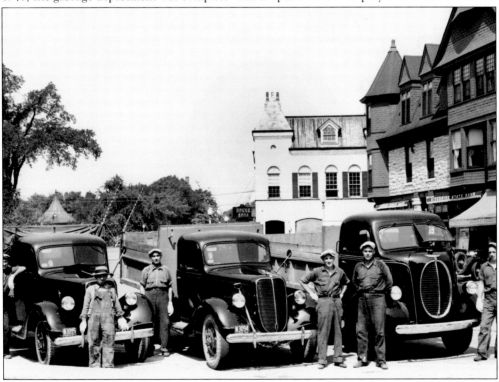

Riverside's antiquated sewer system was becoming problematic by the 1940s. In 1948, workers busied themselves installing new sewer lines in the central business district. (VOR)

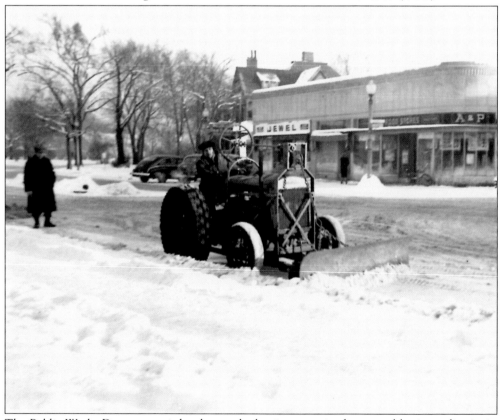

The Public Works Department is hard at work clearing snow in the central business district in this image from December 21, 1942. Note the Jewel and A&P grocery stores at a time when chain stores were becoming prominent. (VOR)

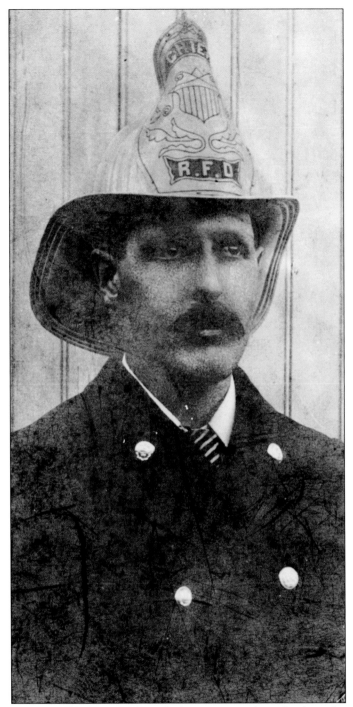

In 1895, Louis Thomas and William Taylor called a meeting at their plumbing shop and organized the volunteer fire department. Thomas became the village's first fire chief, a position he held until 1903. During his years as chief, he championed the improvement of the department's equipment as it transitioned from a volunteer-based organization to a paid-on-call operation. He is pictured here in his full uniform and chief's hat.

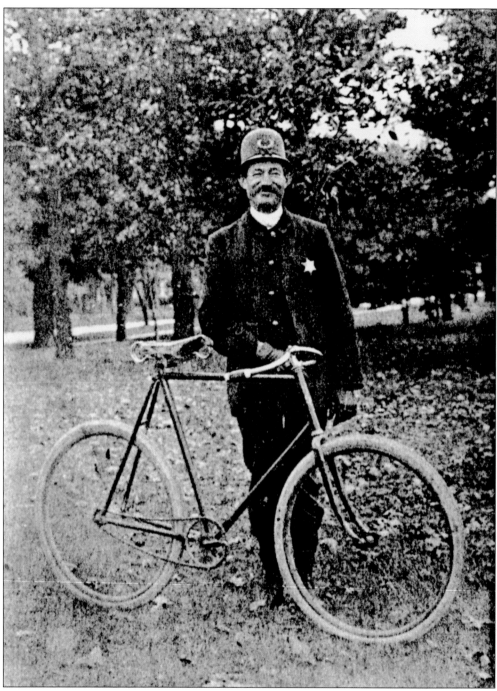

Charlie Lange was a legend in Riverside, working for the police department from 1887 until his retirement in 1927. As Riverside's only police officer, he patrolled the village regularly on his bicycle and knew every resident by name and where they lived. Lange was also known for greeting commuters at the train station every morning and letting kids skinny-dip in the Des Plaines River. In 1887, he was paid $60 a month and given a free uniform. He headed the department until 1925, when the first chief was hired.

The long-vanished "Calaboose" on Bloomingbank Road sat behind the croquet court. The Calaboose served as the village's first jail, and Charlie Lange would often round up the village's errant youths and let them sit here for a few hours until they saw the error of their ways, or until their parents came to claim them.

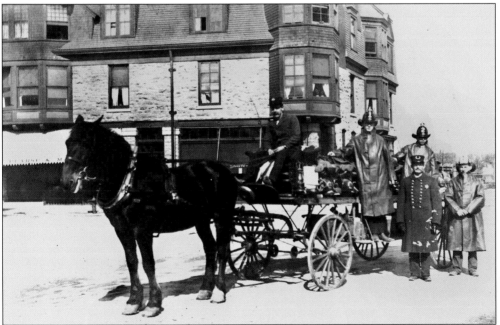

One of Chief Thomas's greatest achievements was convincing the village board to allow the department to use Old Frank, as the village's horse was known, to pull the fire wagon, instead of relying on human volunteers. Here, Old Frank is ready to haul the fire wagon in about 1900 in front of the Malden Block.

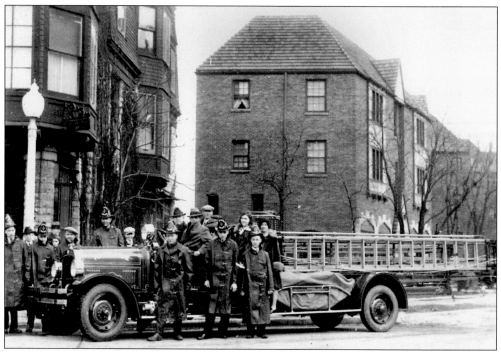

Just 30 years after the era of Old Frank, the fire department had modernized and grown. This February 1930 photograph shows the department posing with their new Seagrave fire truck in front of the Malden Block with the new Seven Gables apartment block in the background. In the driver's seat is the chief, Asa Dearborn, and alongside him is his assistant chief Fred Crowe.

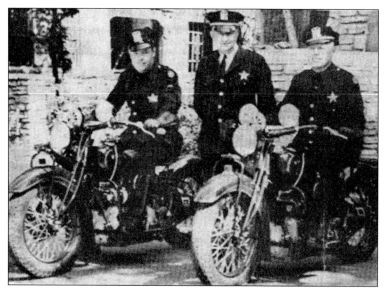

The police department grew professionally along with the village, and motorcycles and squad cars superceded Charlie's bicycle. The first vehicle used by the police was a 1918 Harley-Davidson motorcycle. Pictured are mobile officers Duke Trotter (left), Chief Clarence Neuschafer, and Bill Bartel. (Courtesy of Robert Gordon.)

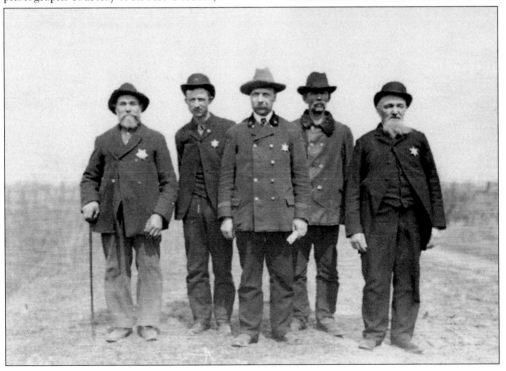

Clarence Neuschafer began his career with the police department in 1905. He is pictured below, second from left, in that same year. Neuschafer quit the department in 1909 to become the watchman at the newly constructed Henry Babson estate. He rejoined the department in 1917 and became chief of police in 1926. He was also an undertaker and maintained a funeral home at 177 Woodside Road. Today, it is a private residence. The photograph on the right shows Neuschafer in his office at Township Hall. (Both photographs courtesy of Robert Gordon.)

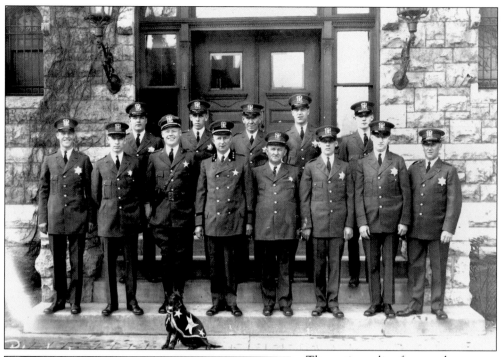

The entire police force and supporting personnel posed for this group portrait on the steps of Riverside Town Hall in July 1927. In the foreground, the department mascot proudly wears his dress uniform.

Another police legend in Riverside was Danny Formato, who served from 1951 to 1981. Danny was known alternately as the "Silver Fox" and as "Jeff" because of his obvious resemblance to Hollywood actor Jeff Chandler. (Courtesy of Robert Gordon.)

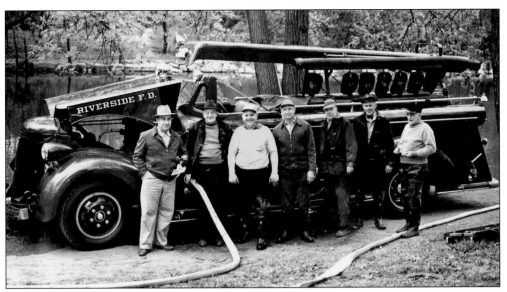

By the 1940s, the Riverside Fire Department's responsibilities included emergency response situations of all kinds, including medical, while still staying in top form with their fire-fighting capabilities. Above, department personnel take a break from their training session in Swan Pond Park in 1947 to pose with Engine No. 1. Below, in 1949, Jimmy Sellers plays the part of the patient as emergency responders demonstrate how to resuscitate him.

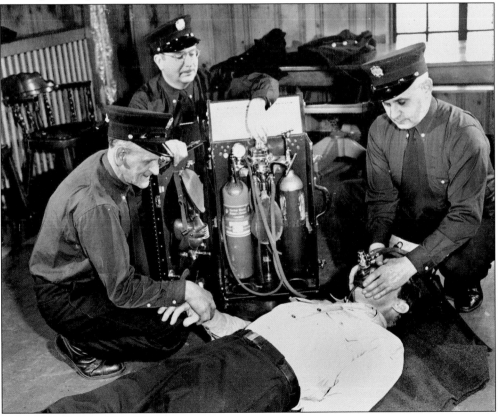

S. Ashley Guthrie moved to Riverside in 1893 at age four and graduated from Northwestern Law School in 1915. After serving in World War I, he became village attorney in 1925, a position he kept until his retirement in 1968. During his tenure, he waived legal fees totaling many thousands of dollars for the village he loved and called home. In 1966, he sat in attendance at the dedication of the downtown park bearing his name.

George Opper was the longest-serving village manager in Riverside's history, serving for 23 years, from 1934 until his retirement in 1957. Above, Opper (right) supervises one of the WPA projects in 1936. Below, he presents the badge of his office to his successor, Alan Sandburg, in 1957. Opper was born in Riverside in 1891, the son of Jake Opper, who operated Riverside's livery service from his stable on Burlington Street. George Opper died in 1993 at the age of 101.

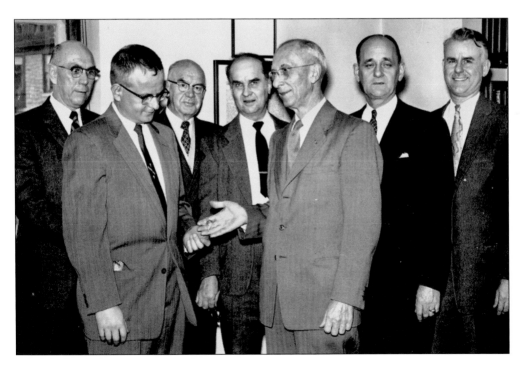

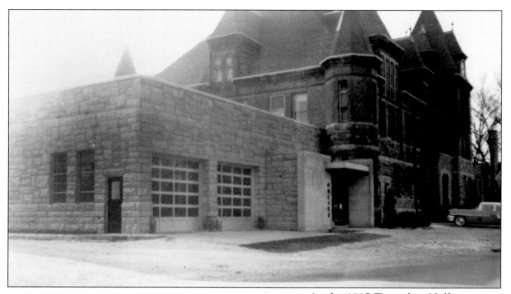

As the 1895 Township Hall was increasingly unable to meet the office space requirements of the village, various additions were built. The new police and fire station addition is shown above in 1955. The new jail, a far cry from the old "Calaboose," is seen left in 1956. (VOR.)

These images show the 1955 garage and workshops before and after the construction of the second-story District 208 Youth Center. Several sites were considered for a facility that would provide recreational afterschool facilities for village teenagers, the lack of which had been a persistent citizen complaint. Since all the sites considered were met with considerable opposition, it was decided to locate the facility atop the new garage/workshop facility. Completed in 1956, the Youth Center became a popular venue for plays and dances. It closed in 1983.

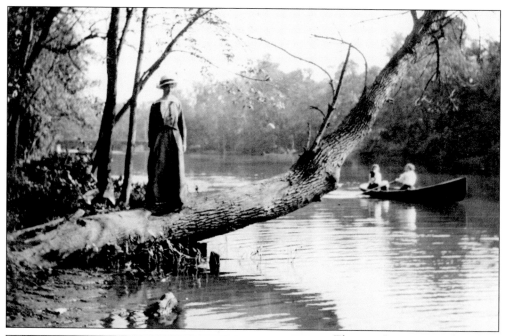

Those seeking quiet solace from the day's activities could always find it easily in Swan Pond Park. Above, Mrs. Sargisson poses on a log adjacent to the river in 1918. Left, a Riverside resident drops a line in the river from the picturesque riverbank.

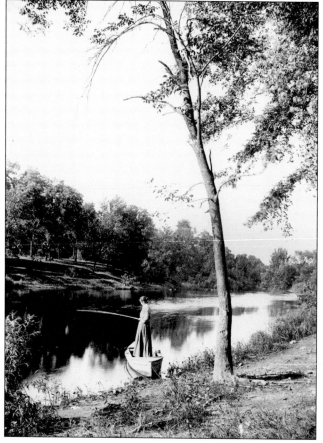

The Des Plaines River provided year-round recreation for the residents of Riverside. Youths often enjoyed a day of ice-skating on it during winter months. As safety issues drove skaters off the river in recent times, skating shifted to less risky areas. The photograph below shows an ice hockey game on the frozen tennis courts at Indian Gardens in the 1970s.

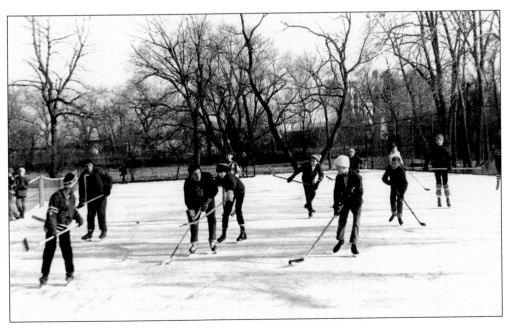

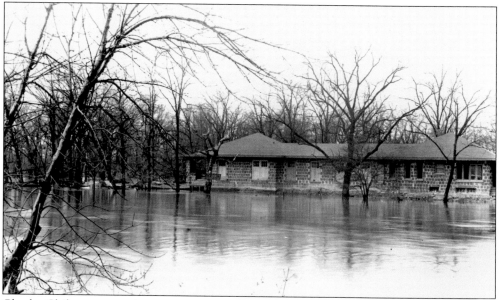

Charles Chilvers operated a canoe-storage and rental facility on the southwest corner of Forest Avenue and the bridge. Mrs. Chilvers, who hailed from Florida, emptied their joint bank account and disappeared. Chilvers pined for his wife for many years, often inquiring at the post office if there was a letter from his "sweetie." Cook County eventually purchased the site and demolished the structures.

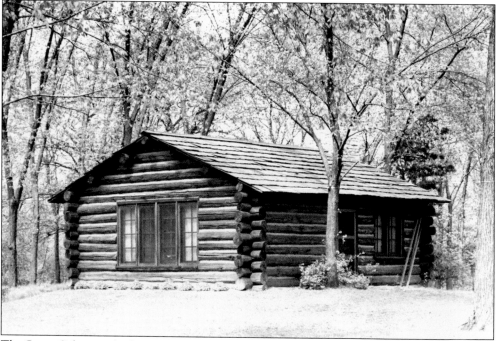

The Scout Cabin was built in 1928 with donated logs as an overnight spot for scouts. It included a totem pole and a fireplace where many a ghost story has been told. The totem pole is no longer there, but the cabin was remodeled in the 2000s and remains a popular site for gatherings. It is now managed by the Parks and Recreation Department.

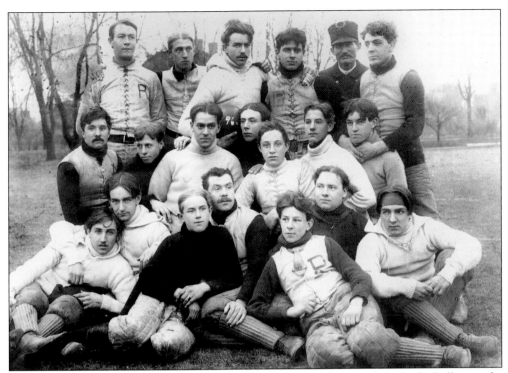

Riverside's athletic teams have proven themselves on the gridiron and the basketball court for more than a century. The Riverside Athletic Club's football team is seen above in 1896 and the Riverside town basketball team is shown below in 1915. The annual football game, played at what is now known as "Big Ball Park" at the north end of the Longcommon Road, was a village tradition for decades, featuring the Riversiders in bright orange and black uniforms.

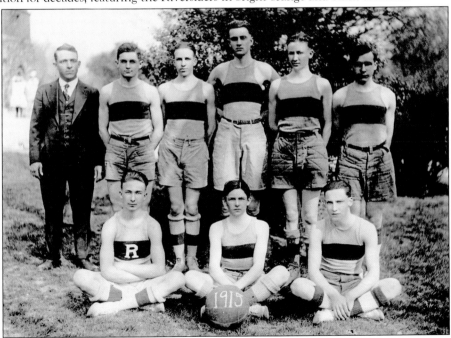

When the old Martin Coal Yard property became available in 1959, a manufacturer of garage doors proposed the construction of a factory on the prominent site. Citizens swung into action and drew up a petition protesting the idea of an industrial facility in the village. The petition drive quickly gathered over 1,000 signatures and successfully derailed the project. In its place, the Riverside Swim Club built this pool and clubhouse in 1962, which they continue to operate as a private facility today. (VOR.)

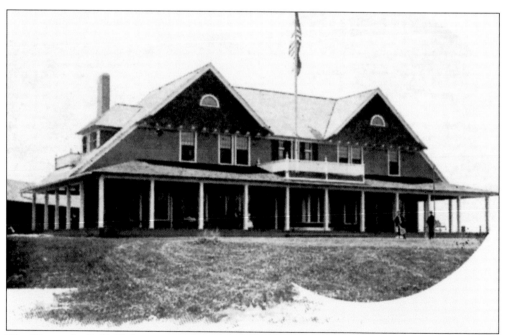

The Riverside Golf Club, organized in 1893, is the second-oldest club west of the Allegheny Mountains. It was reached by driving along an unpaved country road next to Korn's farm. This photograph from around 1901 shows the second clubhouse, built after the first was destroyed by fire. This structure, located at Twenty-sixth Street and First Avenue just north of the village boundaries in present-day North Riverside, also succumbed to fire in 1918, and was rebuilt the following year.

World War II disrupted the idyllic small-town life of thousands of communities across the nation and Riverside was not an exception. The Uhlich children pose with their homemade racecar at their Downing Road home in 1929. Elmer Uhlich is pictured (right) in his Royal Canadian Air Force uniform in 1941. The Uhlich family received the dreaded telegram on November 23, 1941, making Elmer the first Riversider to lose his life in the war.

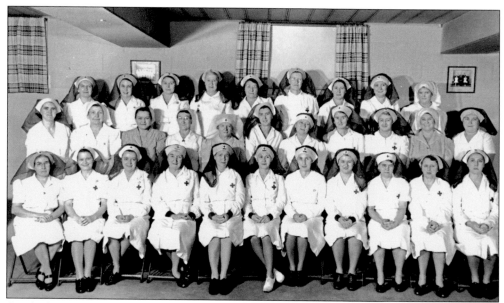

On the home front, the Red Cross Women met in the basement of Ascension Lutheran Church to prepare surgical dressings. Here, the ladies pose for a group photograph in December 1944. They produced approximately 3,000 dressings a month.

Scrap-metal drives for the war effort were already being conducted in Riverside just nine months into the war, as this September 1942 photograph illustrates. From left to right, John Sentz, Bill Porte, and Harold Nielsen show off their haul on the Neilsens heavily weighted-down panel delivery truck.

Four

GOING TO CHURCH, GOING TO SCHOOL

Riverside has a long tradition of pride in both its educational achievements and its religious denominational diversity, and both have been an integral part of the community's fabric since the founding of the village. A house of worship, known as the Stone Chapel or the Union Church, has existed in Riverside since the days of the Riverside Improvement Company, which hoped to encourage an ecumenical arrangement among the various Christian denominations. As soon as 1872, this arrangement proved inadequate and the desire for separate facilities became apparent, with the Presbyterians eventually purchasing the Stone Chapel for their exclusive use.

Besides the Presbyterians, the mainline denominations represented today include Roman Catholics, Episcopalians, Lutherans, Evangelical Lutherans, and Methodists. In a second stab at ecumenism, the Christian churches of Riverside and North Riverside signed a Covenant of Churches document providing for cooperation in 1985.

Educational initiatives predate the founding of the village. As early as 1836, 11-year-old Flavilla Forbes, the daughter of pioneer Stephen Forbes, conducted classes for her young cousins. In 1871, the first public school opened in the Arcade Building, expanding in 1878 to include high school students. In 1874, a two-story wooden schoolhouse was built on Forest Avenue. As enrollment grew, this facility soon proved obsolete, and a new three-story brick building was erected on Woodside Road. It burned down in 1896 and was succeeded by the current Central School building that opened the following year. The new building housed the grammar school in the west wing as well as 19 high school students, who had been conducting their classes at the town hall while the new school was under construction. This arrangement lasted until 1918, when high school classes were transferred to the newly built Riverside-Brookfield High School.

Private educational initiatives in Riverside consisted of Queene Ferry Coonley's Cottage School (1909–1919), which followed the progressive teaching methods of John Dewey, and St. Mary's Roman Catholic School, founded in 1926 and still educating Riverside's youth today. Besides Central School, the current K-8 public school system in Riverside includes Ames School, Blythe Park School, and Hauser Middle School.

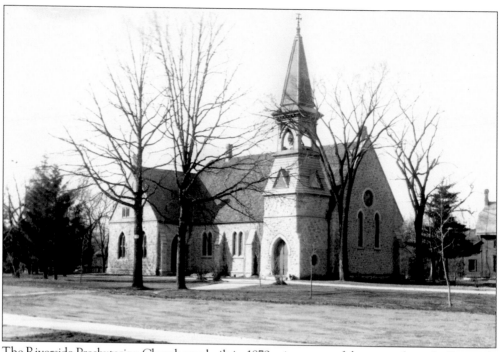

The Riverside Presbyterian Church was built in 1879 using many of the stones from the Riverside Improvement Company's Union Church, which burned in 1878, shortly after it was purchased by the Presbyterians. Prominent Chicago architect John Cochrane was responsible for the design of the new building, which was built at the same Barrypoint location as the original Union Church. It is shown above prior to extensive remodeling, the last of which was completed after a 1969 fire. The manse (below, right) was added in 1897.

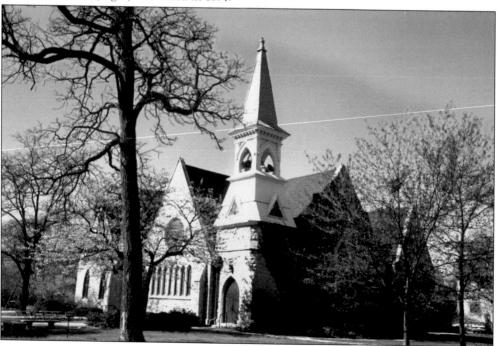

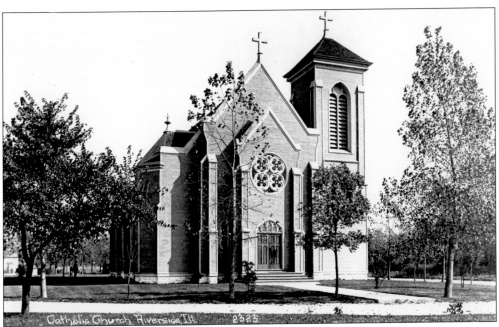

St. Mary's Roman Catholic Church had its beginnings in neighboring Lyons in 1873, when it was served by missionary priests arriving on horseback from Chicago. In 1901, the congregation moved to the above building, at the east end of Blackhawk Road. That structure was demolished in 1928 after the parish built a new centrally located combination church-and-school building on Herrick Road (below). The new building, designed by Harry Robinson, was dedicated in the presence of His Eminence George Cardinal Mundelein on September 12, 1926. A $2.9-million expansion in 1997 gave the complex its current configuration.

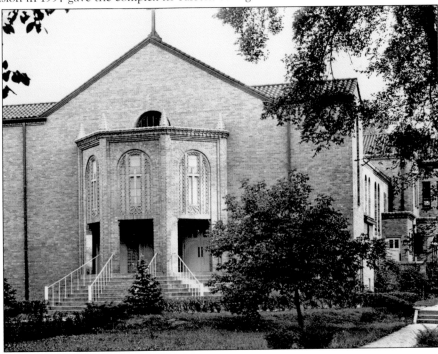

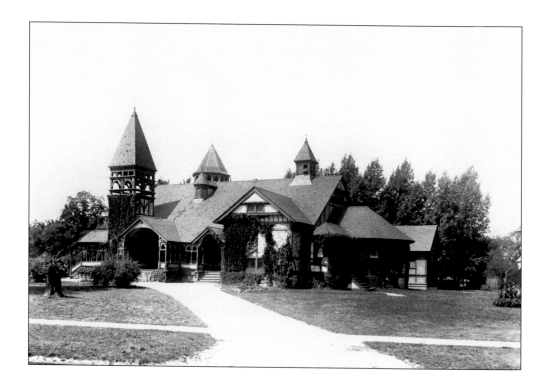

Episcopalians held services in both the old Riverside Hotel and the Union Church before constructing this basilica-style country parish church from 1882 to 1888. William LeBaron Jenney donated the plans for the building and Jarvis Hunt designed the rectory, completed in 1895. The above image shows the church in its original Jenney form. The below image shows it after several alterations were made between 1930 and 1957. (VOR.)

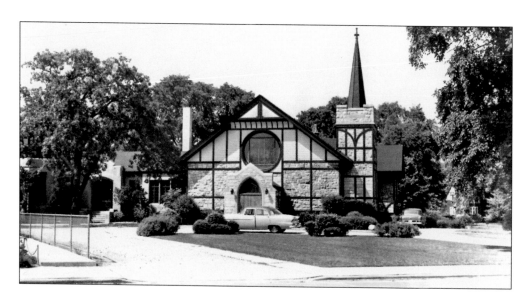

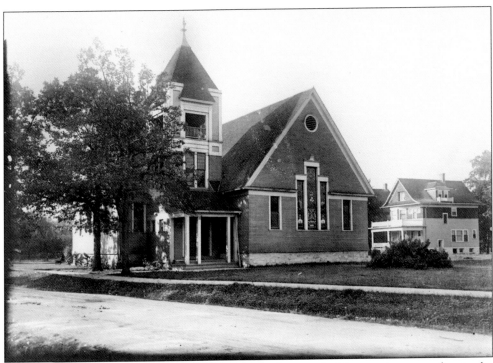

Like the Episcopalians before them, the Methodists also searched for meeting space, first in the Arcade Building and later in Township Hall, before building their own church at Woodside Road and Park Place in 1901, seen above in 1924. Significant growth in membership necessitated plans for a new church in the mid-1950s. Bishop Charles Brashares consecrated the new church (below) on October 23, 1960, completely free of debt.

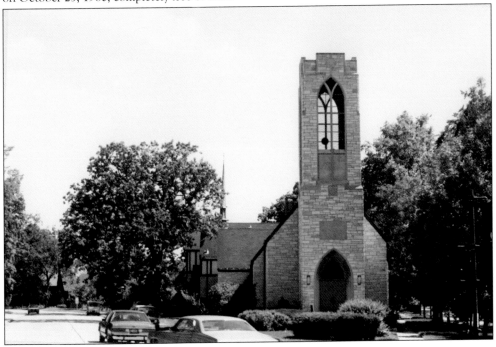

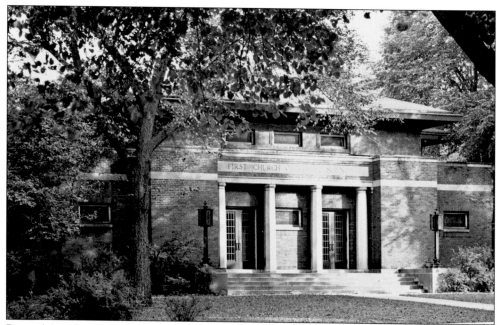

Beautiful and serene, the former First Church of Christ Science occupies a prime location at 135 Longcommon Road. The 1920 Prairie-style structure is the work of Howard Cheney, better known for designing airport hangars. Avery and Queene Ferry Coonley were parishioners and were instrumental in financing the construction. The Christ Scientists left Riverside in 1992 and the building is now a private residence.

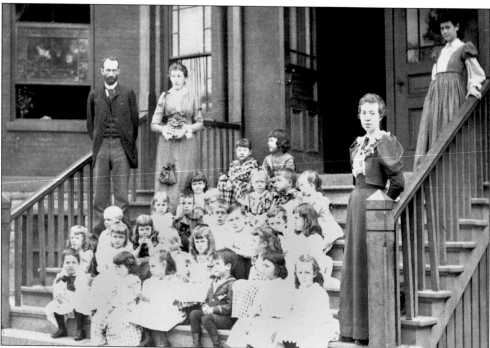

Harold P. Gould's kindergarten class poses on the steps of the Riverside Common School on a spring day in 1894. Principal A.F. Ames stands on the left, alongside teacher Miss Watson.

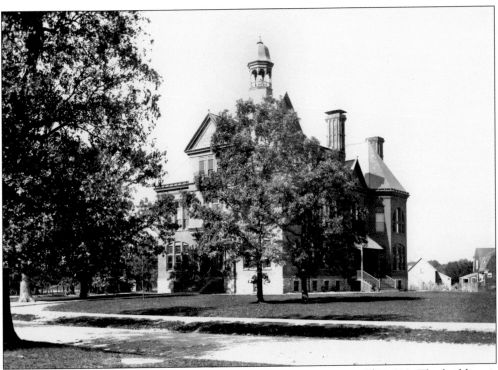

The Riverside Common School (above) was built in 1884 at a cost of $22,500. The building is capped with a wooden belfry, which also served to summon volunteer firefighters to the scene of a fire. When fire struck the school in 1896, the belfry crashed into the lower stories before the bell could call the firemen. By the time the fire was extinguished, the school was a total ruin (below) and nearly 400 students were relocated to Township Hall for class.

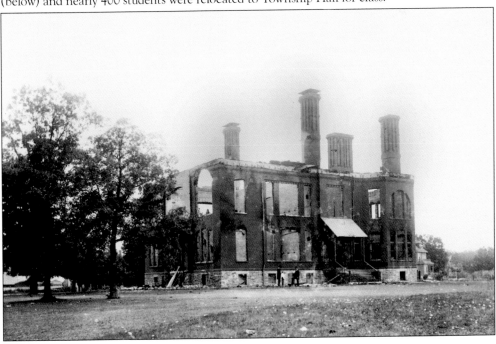

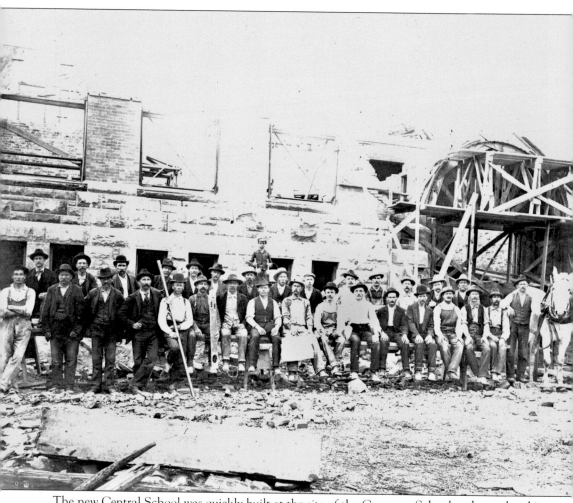

The new Central School was quickly built at the site of the Common School and completed in 1897. Here, man and beast take a breather during construction.

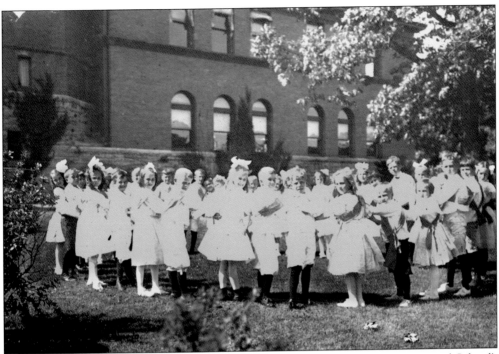

Wayland Evans's class, all decked in white dress, performs an outdoor play on Central School's front lawn in 1914.

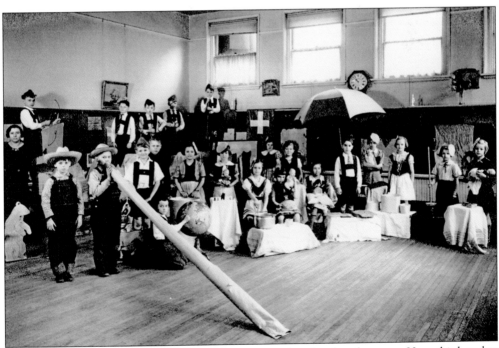

During weekly assembly, each class took turns giving an educational performance. Here, third-graders demonstrate what they have learned about Switzerland.

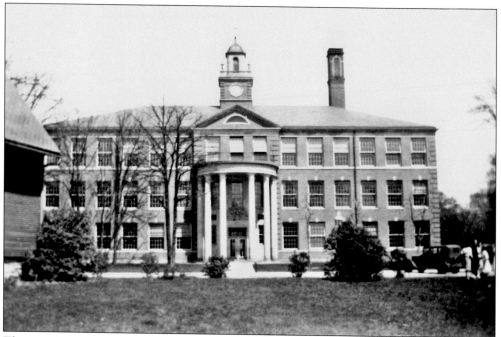

The new Intermediate School was completed in 1929. Following the new departmentalized methodology, grades seven and eight occupied the first two floors and sixth grade was assigned to the third floor. In 1963, the school was renamed after longtime principal L.J. Hauser upon his retirement. The school was expanded in 1968.

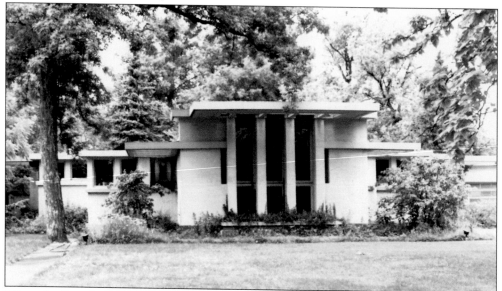

When the Coonley's Cottage School proved too small for its growing enrollment, the Coonleys had Frank Lloyd Wright design a new school, commonly known as the "Playhouse," complete with a stage where students could physically perform what they had learned. The school was finished in 1912 and used by the Cottage School until 1919, when a new school by William Drummond was built in Brookfield. Wright's Playhouse has been modified and converted into a private residence.

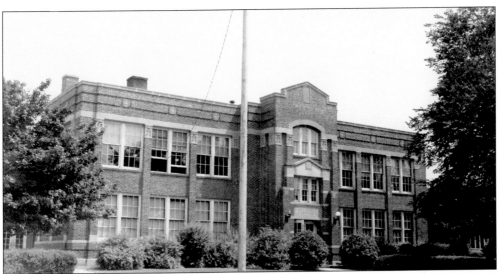

As the northern portion of the village began to experience growth, a new school was constructed in 1923 to serve kindergarten through fifth grade, freeing up space at Central School. The new school was named after superintendent A.F. Ames and expanded in 1968.

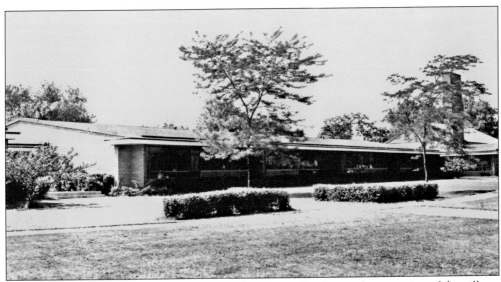

Another new school, Blythe Park, was deemed necessary for the northern portion of the village. The innovative firm of Perkins and Will designed the modern facility in 1948, taking full advantage of the park setting and including facilities intended to benefit the entire community, including an amphitheater. (VOR.)

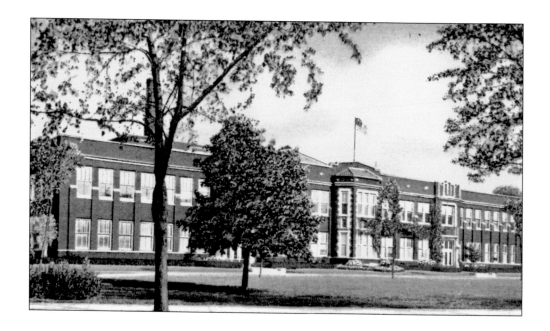

As the need for a separate facility to house high school students became apparent, a site west of the Des Plaines River was selected that would serve both Riverside and its neighbor to the west, Brookfield. The upper photograph depicts the new Riverside-Brookfield High School on September 22, 1918, just after its completion. The school has undergone many additions and modifications in its more than 90 years of existence. The 1954 addition is shown below.

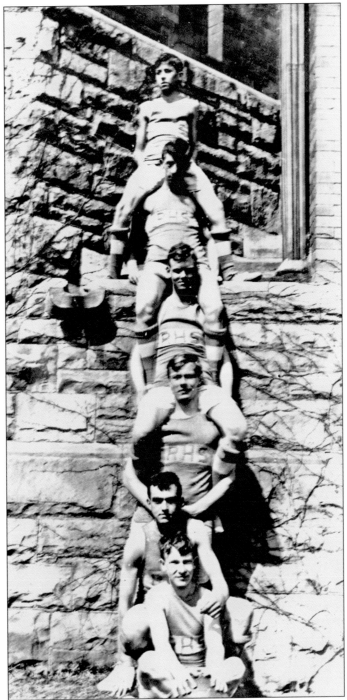

Sports have been an integral part of extracurricular activity in Riverside ever since the first students picked up a book. The Riverside High School basketball team poses outside of Central School in 1909. They are, from top to bottom, Gaylord Miliken, George Opper (who would become Riverside's longest-serving village manager), Jack Moore, Walter Scoville, Joel Childs, and Melvin Evans. (RBHS.)

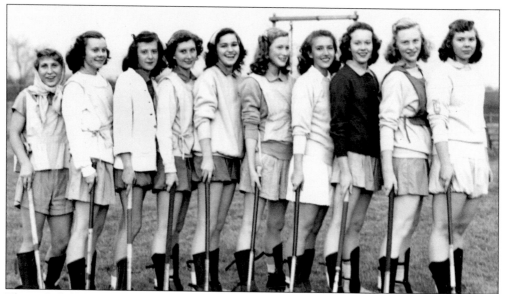

This girls field hockey team poses for a group photograph. (RBHS.)

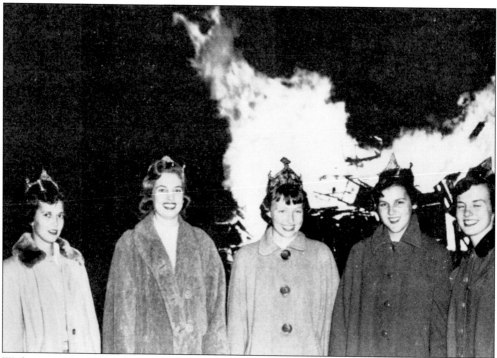

With its parade, football game, and evening dance, homecoming provides many memories of high school days. The 1954 homecoming queen and her court enjoy the traditional bonfire as they get ready to make some memories of their own. (RBHS.)

Five

CELEBRATING AND SUSTAINING A NATIONAL LANDMARK

By 1950, Riverside had expanded to its current boundaries of Harlem Avenue to the east, Golf Road to the west, Twenty-sixth Street to the north, and Ogden Avenue to the south. Since further growth could only occur within these confines, the rate of growth slowed and crested at 10,432 in 1970, after which it began a gradual decline to its 2010 level of 8,825. With the focus off growth, Riverside began looking at its past in appreciation for the special qualities that both defined its beginnings and continue to guide its future.

Depending on one's perspective, Riverside celebrated its centennial either five years late or 39 years early when a group of citizens and civic organizations, headed by Dr. S.S. Fuller, staged a celebratory 1936 pageant of events commemorating early settlement of the area. As the 1936 centennial awakened interest in the area's history, the Riverside Historical Society was founded in 1937. In 1969, the society occupied the East Well House and converted it into a museum. The society continued in operation until the village created the Riverside Historical Commission in 1971, after which the society dissolved and transferred its assets to the commission. The centennial of Riverside's incorporation as a village was in 1975, when another centennial celebration was held. Water Works Park, the land around the old water tower and well houses, was renamed Centennial Square in anticipation of the event.

With many of Riverside's pioneer homes demolished or lost to fire, the need to preserve and restore the remaining links to the past came to be viewed as not only desirable but imperative. A heroic and ultimately successful effort to save Frank Lloyd Wright's Avery Coonley estate was mounted by James and Carolyn Howlett in the 1950s. Unfortunately, the success achieved at the Coonley estate was not matched by efforts to save Louis Sullivan's 28-acre Henry Babson estate. It was lost to the wrecking ball in 1960. Riverside finally created a preservation ordinance in 1991 and established the preservation commission to oversee local landmarks.

Robert Heidrich, founder and first president of the Frederick Law Olmsted Society of Riverside, submitted an application to the National Park Service in 1969 to have Riverside designated as a National Historic Landmark. He did so as a private citizen and without the cooperation or knowledge of the village board. In August 1970, the application was accepted and Heidrich announced it in the press, once again without the village board's knowledge. It was not until March 20, 1972, that the village board passed a resolution officially accepting the designation of the Riverside Historic District. Riverside is viewed today as the quintessential American commuter suburb, whose fine design conveys both Olmsted's egalitarian spirit and a sense of community among those who are fortunate to have dwelt in its midst.

111

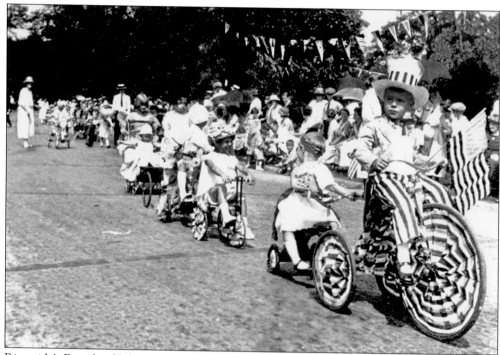

Riverside's Fourth of July parades are legendary as young and old turn out for a village-wide celebration. This 1922 parade photograph shows one of the parade's traditions, the "Teenie-Weenie" portion of the parade, where the village's youngest citizens decorate their bicycles and show off the results.

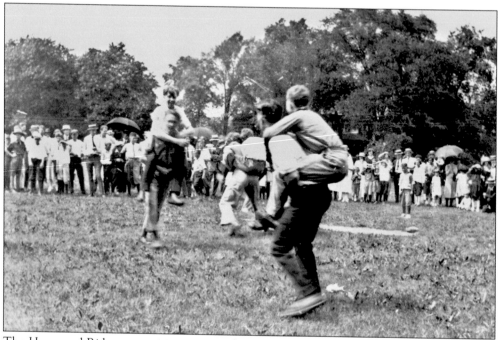

The Horse and Rider competition was another popular tradition, shown in this image of the 1923 Fourth of July activities.

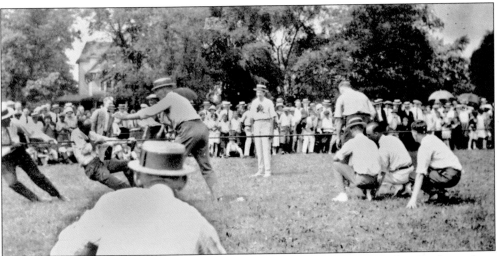

In their white shirts, ties, and straw hats, the men of Riverside engage in a battle of tug-of-war after the Fourth of July parade in 1923.

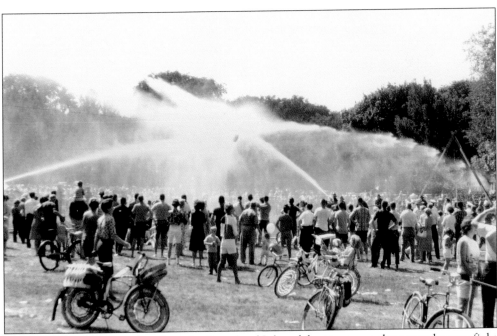

Another competition integral to the Fourth of July celebrations was the annual water fight held at Loncommon Park, pictured here in 1998. The Riverside Fire Department battles a neighboring municipality, dueling with water hoses to force a suspended overhead barrel to the side of their opponent.

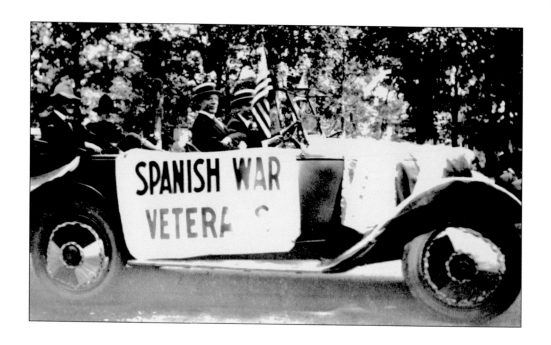

There is a somber aspect to the Fourth of July celebrations as the town honors the men and women who have fought to defend the nation. Veterans of the Civil War (below) and the Spanish-American War (above) ride in open cars along the parade route in 1923.

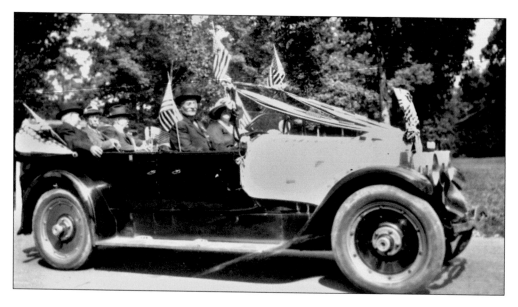

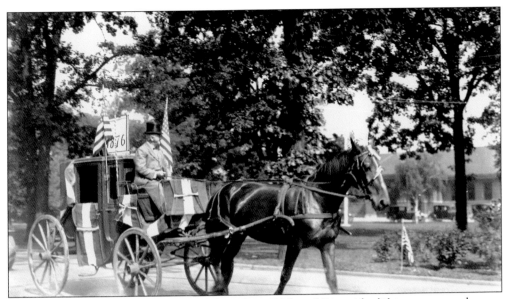

The national sesquicentennial was celebrated in 1926, and Riverside did its part to make sure everyone knew it. Here, livery operator Jake Opper rides along the parade route in his decorated horse and Victoria carriage.

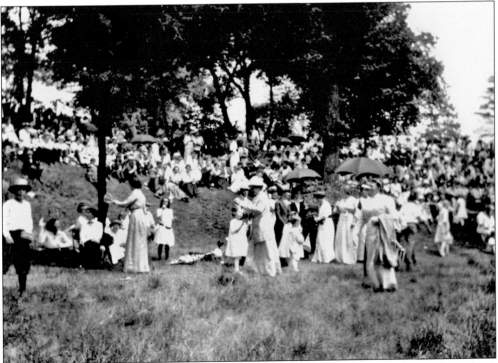

Crowds of Riversiders jam into Swan Pond Park to enjoy the festivities after the 1915 parade. A news article estimated the crowd at 3,000. They had plenty to enjoy: a band playing patriotic music, a baseball game, a water carnival at the river, and fireworks at sundown.

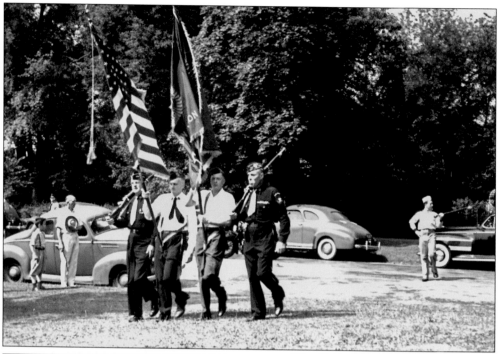

The 1944 celebration was held while the war was still ongoing in Europe and Asia. Above, the color guard takes the field with flags unfurled. War must have seemed a distant distraction to the youngsters left as they engaged in the traditional pie-eating contest.

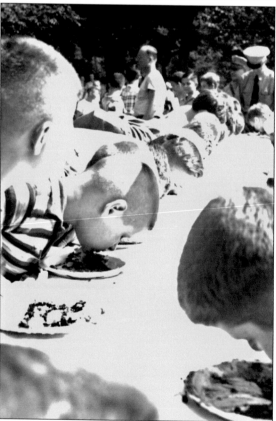

Riverside held a pageant in 1932 commemorating the early settlement of the area. In the right photograph of the festivities, the Boy Scouts reenacted the crossing of the Des Plaines River at the traditional ford just below Fairbank Road at the site of the little dam. The Women's Reading Club dedicated a marker at the site (below). It reads, "This boulder marks the old river crossing used by the Indians on the trail from north to south by the fur traders and by the early settlers in the development of the west."

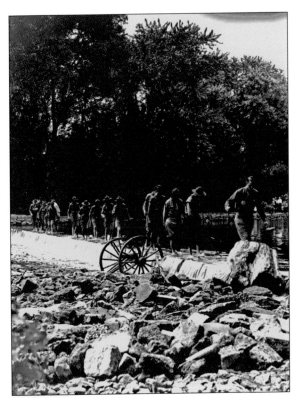

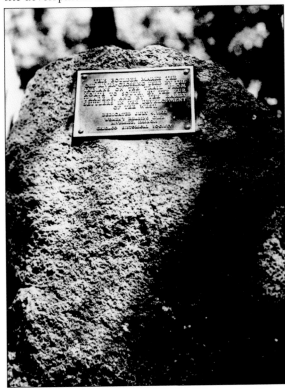

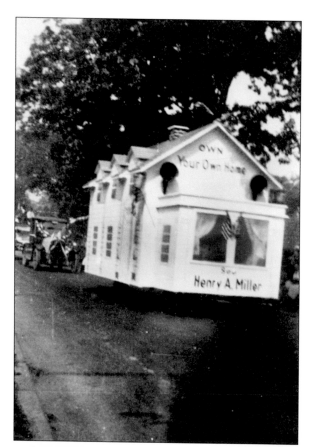

The 1936 centennial celebration was a community affair driven by Dr S.S. Fuller, who compiled a book titled *Riverside Then and Now* to commemorate the event. Miller Realty's float encouraged everyone to "Own Your Own Home." The Pure Oil float made its way down Burlington Street in the same parade.

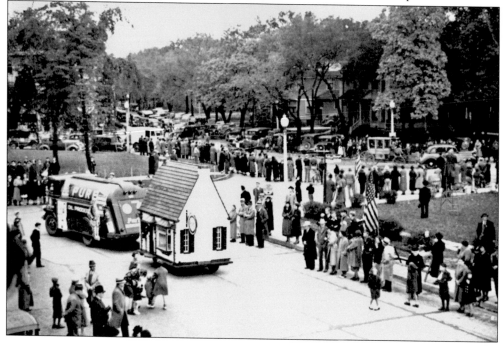

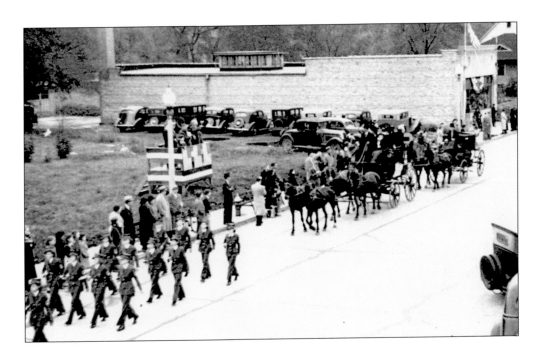

The Riverside Lions Club joined in the 1936 centennial parade, providing the entertaining float below. Above, horse-drawn carriages parade past the reviewing stand on Burlington Street. Barely visible in the stands are Dr. S.S. Fuller and Judge John Lewe.

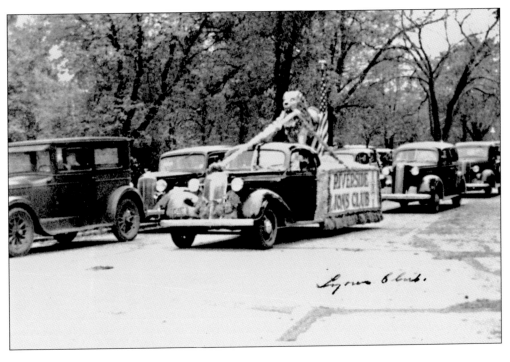

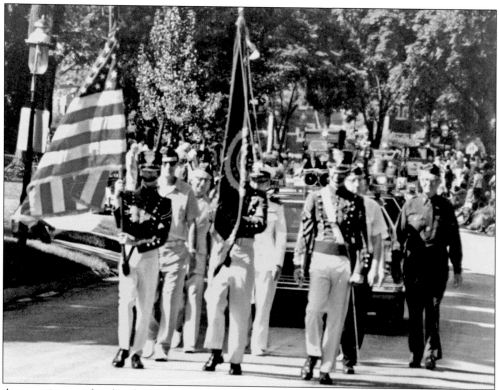

A committee under the chairmanship of Charles Clawson planned the 1975 celebration of the centennial of the village's incorporation. Beginning with the Centennial Ball in January, the events culminated with a grand parade held on August 10. Here, the color guard, at the head of the parade, proudly takes the lead.

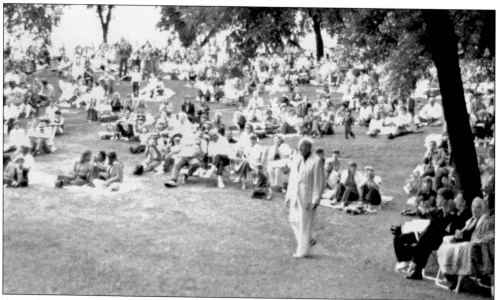

Attendees gathered on the slopes of Swan Pond Park to await the speeches and activities following the centennial parade in 1975.

Riverside's annual Holiday Stroll is sponsored by the chamber of commerce and traditionally occurs on the first weekend of December. In 1980, Santa Claus arrived in style with Riverside's antique fire truck.

Louis Y. Schermerhorn, partner in the firm of Jenney, Schermerhorn, and Bogart hired by the Riverside Improvement Company to implement Olmsted's plan for Riverside, received this lot on Scottswood Road in payment for his services to the company. William LeBaron Jenney designed this home for Schermerhorn in 1869, making it one of the earliest structures completed in the village. It remains remarkably intact, as does the original 100-foot lot on which it sits.

Calvert Vaux, Olmsted's partner at the time of the Riverside commission, designed this home for John Clarke Dore in 1869. Dore was the first superintendent of the Chicago Public Schools, an Illinois state senator, and the president of the Chicago Board of Trade. This is the only surviving Vaux home in Riverside out of the three originally built.

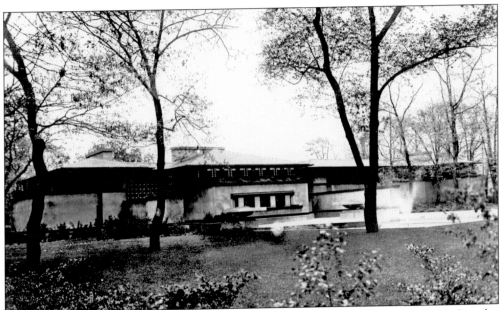

This outstanding Prairie-style home was designed by Frank Lloyd Wright for Avery Coonley and his family in 1907–1908 with interior furnishings by Niedecken of Milwaukee. Jens Jensen landscaped the seven-acre estate. The estate was acquired by developer Arnold Skow in 1952 and threatened with demolition. It was saved primarily through the effort of James and Carolyn Howlett, who came to reside in one of the service buildings when the estate was subdivided and the demolition called off. The structure was named a National Landmark in 1971.

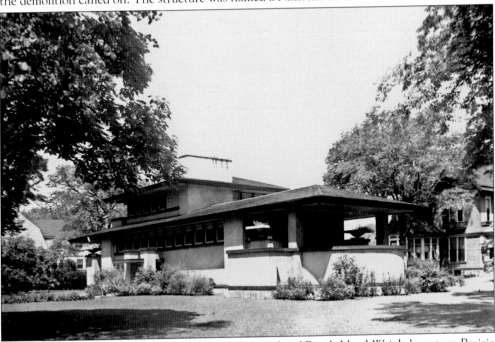

The Ferdinand Tomek house is another fine example of Frank Lloyd Wright's mature Prairie style of architecture. Tomek owned a wood-molding firm and had Wright build this home for his family in 1905–1906. This home was designated a National Landmark in 1999.

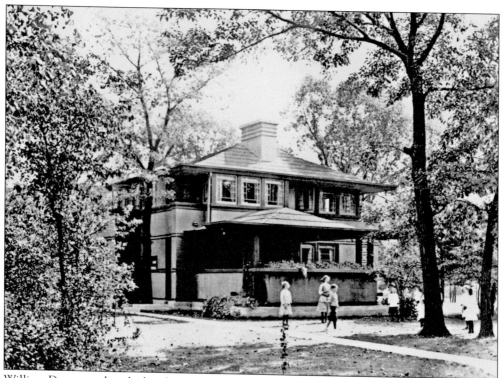

William Drummond worked under Frank Lloyd Wright when Wright designed the Avery Coonley estate. In 1912, the Coonleys hired the firm of Drummond and Guenzel to design Thorncroft, the residence for the educators employed by Mrs. Coonley at her Cottage School. It is now a private residence and one of Riverside's premier Prairie-style homes.

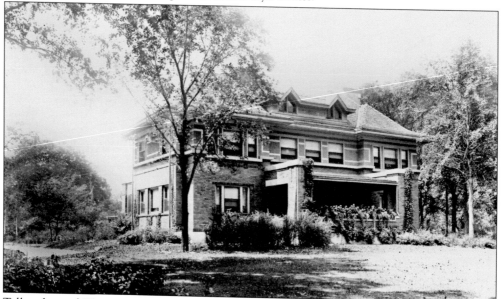

Tallmadge and Watson was another of the major architectural firms working in Riverside. They designed this home, built for Fred Babson in 1908 on Addison Road. Babson's brother, Henry, owned a large estate on Longcommon Road.

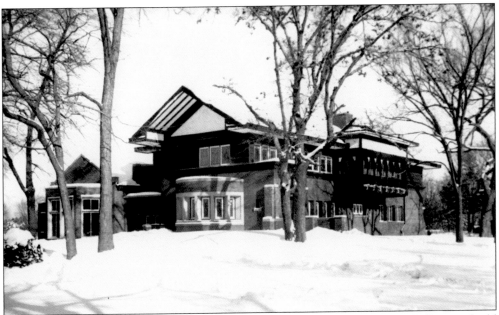

Wealthy phonograph distributor Henry Babson engaged famed architect Louis Sullivan to build the above home, shown here in 1907, on the site of the recently demolished house of Emery Childs, president of the Riverside Improvement Company. It had 25 rooms, a dining room paneled in walnut, and marble stairs leading to the ballroom. The 28-acre estate featured a three-hole golf course and strolling peacocks. It was razed in 1960. The service buildings (below) were built by Purcell and Elmslie in 1915 and were converted into private residences in the 1930s. They remain so today.

Riverside's beloved Swan Pond Park is a floodplain. As communities along the river pave over more land for development, water is pushed southward and flood events become more frequent and severe in Riverside. In 1986 and 1987, Riverside suffered "100 year floods" in back-to-back years. Above, students and their fellow residents work alongside each other to sandbag the riverbank on West Avenue. In contrast, the grove of trees pictured below invites residents and visitors to partake in a leisurely stroll amidst the verdant and bucolic winding roads of Riverside, imparting peace and tranquility.

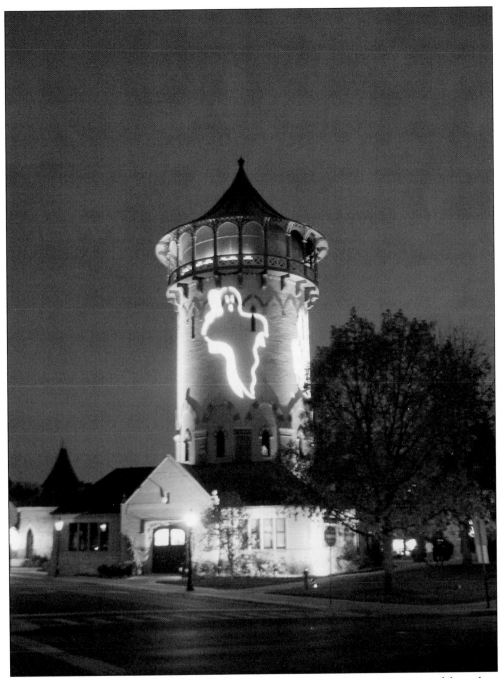

Taken on Halloween night in 2011, the old water tower, a Riverside icon, now retired from duty and restored to its former elegance, is bathed in Halloween orange as the ghosts of Riverside's past remind us of our proud heritage. (Courtesy of James Reynolds.)

DISCOVER THOUSANDS OF LOCAL HISTORY BOOKS FEATURING MILLIONS OF VINTAGE IMAGES

Arcadia Publishing, the leading local history publisher in the United States, is committed to making history accessible and meaningful through publishing books that celebrate and preserve the heritage of America's people and places.

Find more books like this at
www.arcadiapublishing.com

Search for your hometown history, your old stomping grounds, and even your favorite sports team.